IMAGES
of America

INDIANA'S CATHOLIC
RELIGIOUS COMMUNITIES

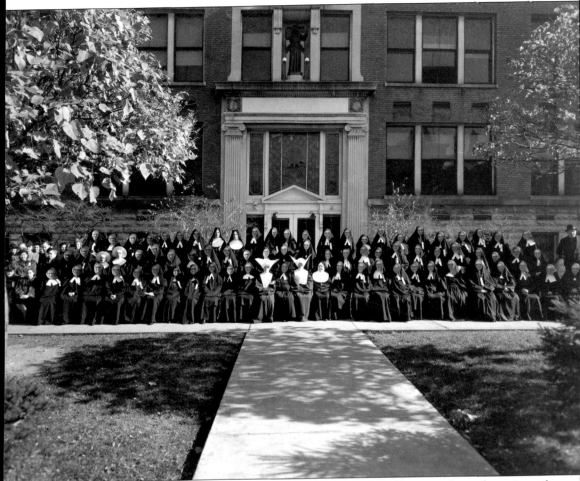

This group photograph taken at St. Francis College, Lafayette, illustrates the wide variety of Catholic religious communities that were providing educational and health services in Indiana in the 1940s. Distinguished as different by their habits, while joined by their common purpose to serve others, they formed the core of health, education, and social services throughout the state of Indiana. (Sisters of St. Francis, Mishawaka.)

On the cover: The year 1956 had hardly begun when Sister Alexia, realizing the need for funds to furnish the interior of the new wing being constructed at St. Francis Hospital in Beech Grove, suggested that the St. Francis Hospital Guild raffle a new Cadillac sedan, selling tickets in the form of "bricks" to raise the needed funds. (Beech Grove Public Library.)

IMAGES
of America

INDIANA'S CATHOLIC
RELIGIOUS COMMUNITIES

Jim Hillman and John Murphy

ARCADIA
PUBLISHING

Published by Arcadia Publishing
Charleston SC, Chicago IL, Portsmouth NH, San Francisco CA

Printed in the United States of America

Library of Congress Control Number: 2009925361

For all general information contact Arcadia Publishing at:
Telephone 843-853-2070
Fax 843-853-0044
E-mail sales@arcadiapublishing.com
For customer service and orders:
Toll-Free 1-888-313-2665

Visit us on the Internet at www.arcadiapublishing.com

To all the religious who dedicated their lives to the welfare of others and to present and future generations so that these works may always be remembered.

CONTENTS

ACKNOWLEDGMENTS

We began this work believing that as lifelong Catholics, and both having the benefit of many years of Catholic education, we knew a story that needed to be told. As we began to visit the various communities we quickly realized that the sisters, brothers, priests, and friars all had much more to teach us, so we became students once again.

This book would not have been possible without the hospitality and assistance of all the religious communities across the state. We were privileged not only to access the photographic archives but also to pray and dine with the members and to engage in open and frank discussions about the lives and missions of the communities and their members in times past and in the present day. In these visits we were able to gain the insights to present not only the historical facts but also the context and spirit of those events.

For all this cooperation we are grateful to each and every sister, brother, priest, and friar who gave freely of their time, knowledge, and advice in the compilation of this book. There are a few individuals we encountered who deserve mention not just because they assisted our research; these are the rare people who have about them an aura of holiness, joy, and fulfillment in their chosen life. Our special thanks to Father Cyprian, and Sister Mary Dominic, who embody the scholarly and joyful spirits of the religious communities, and to Sister Rose Marie, in whose presence we felt true holiness.

We also wish to take this opportunity to express our eternal gratitude to the multitude of sisters, brothers, priests, and friars who taught us reading, writing, and arithmetic; gave us our religious instruction; and inspired us to undertake this work.

INTRODUCTION

As the United States expanded in the early 1800s, the state of Indiana was carved out of the generally unpopulated area known as the Indiana Territory. With statehood came a new and very different immigrant population. Families with children replaced the solitary trappers and traders, and many of the immigrants who were young and healthy when they came to the state inevitably aged, were injured, or became ill. Schools, hospitals, and other social services were nonexistent, and the fledgling state and local governments were ill prepared to address these issues at this early stage of development.

In 1834, the Roman Catholic Church created the Diocese of Vincennes and appointed Simon Gabriel Bruté as the first bishop. The newly formed diocese included all of Indiana, and a portion of the eastern side of Illinois, including the village of Chicago on Lake Michigan. While this appointment may have been a generally unremarkable event to most of the population, it would have ramifications in the lives of virtually every citizen of Indiana for the next century and more

Bishop Bruté was a scholar who had been educated as a medical doctor prior to his seminary education in his native France. In Bruté, Indiana had acquired a leader who understood that although his official capacity was as a spiritual leader, the temporal needs of the population could not be ignored. Bruté knew from his own experience the value of education and medical care, and he knew that within the church there were resources to address these needs in his developing diocese.

In the whole of the diocese there was just one academy at Vincennes that had been established by the Sisters of Charity from Nazareth, Kentucky, who had abandoned the effort due to a lack of financial support. Bruté was able to convince the sisters to return to Vincennes to reopen the academy and then personally departed on a trip to his native Europe. He sought financial assistance and met with the various religious communities seeking missionary efforts to his diocese.

Unfortunately, Bruté would die before the seeds he planted bore fruit, but his efforts had set in motion a series of events that would shape education, healthcare, and social services in Indiana to the present day. Over the next few decades the European religious communities would arrive at numerous locations to establish permanent facilities and begin serving the people of Indiana.

The Sisters of Providence arrived at the village of St. Mary on the Wabash River near Terre Haute. They established an academy that would later become St. Mary of the Woods College. To the north, priests of the Congregation of Holy Cross arrived at South Bend to open a school that would grow to become the University of Notre Dame. Brothers and Sisters of the Congregation of Holy Cross joined the priests in South Bend and created Holy Cross College, Saint Mary College, and St. Joseph Hospital in South Bend.

The southeastern part of the state had seen an influx of German immigrants and Benedictine monks arrive in the area to establish an abbey at St. Meinrad that would open a seminary. Over time the monastery would include a commercial college, extensive farms, coal mines, a publishing house, and a substantial sandstone quarry operation, all of which provided not only a spiritual center but also employment to local farmers and craftsmen.

The Sisters of St. Francis came to Oldenburg to open an academy, staff schools throughout the state, and establish a college that grew and relocated to become Marian University in Indianapolis. A few years later, the Sisters of St. Benedict established a convent and academy in Ferdinand. The sisters soon were staffing schools in the nearby communities, expanding their academy, and establishing a college for teacher education.

The Ohio River along the state's southern border was a major transportation route, making Evansville a growing commercial port and industrial center. Local business leaders saw a need for medical services, and a group of Daughters of Charity arrived to open a clinic that has grown to be St. Mary's Medical Center. From that first hospital, a group traveled to Indianapolis to open an infirmary that would become St. Vincent Hospital.

The Little Sisters of the Poor made their first entry into Indiana in Indianapolis to open a home for the elderly poor, and a few years later a group of the sisters came to Evansville to open a similar facility. At Lafayette, the Sisters of St. Francis opened St. Elizabeth Hospital, added a nursing school, and then established St. Francis Hospital in Beech Grove. The sisters relocated their convent to Mishawaka and combined all the medical services into the Sisters of St. Francis Health Services with headquarters in Mishawaka. Over the years, the sisters also staffed a number of schools and established St. Francis College at Lafayette (later relocated to Fort Wayne).

At other places across the state, schools and medical facilities were opened at Mount St. Francis by the Conventual Franciscans and at Tipton by the Sisters of St. Joseph. At Evansville, Kokomo, Indianapolis, and Terre Haute the contemplative Poor Clares and Carmelites began their work of continual prayer and provision of essential services to the church, such as making vestments and altar goods. Near Gary, the Albertine sisters, the Salvatorian fathers, and the Carmelite Fathers established facilities for spiritual care and service to the poor. In Huntington, the newly founded Our Lady of Victory Missionary Sisters established its motherhouse from which sisters primarily served the Native American population in the western states. At Bloomington, the Franciscan Friars and Sisters of the Immaculate have established a retreat center, convent, and friary.

It has now been nearly 175 years since Bishop Bruté first made his requests for assistance from the religious communities; the response to his call brought the sisters, brothers, priests, and friars who not only built the Catholic church in Indiana but also created many of the state's premier educational and healthcare systems that serve all the residents.

Changes over the years have gradually made many of the religious a bit less visible to the general public as their dress has changed to adapt to missions that have taken new directions to address the present social needs. The students educated in their schools have become the teachers, doctors, nurses, and administrators who operate the schools and hospitals they founded. But among the poorest of the poor, men and women in the familiar habits are still seen teaching the children, feeding the hungry, comforting the sick, and holding the hands of the dying.

This book is not intended as a comprehensive or detailed history of the Catholic Church in Indiana, or any particular religious community, but rather as an overview of the results of the collective efforts of these extraordinary souls who dedicated their lives to providing for others. Our hope is that the reader will gain a greater appreciation for the significance of the Catholic religious communities in the transformation of the territorial wilderness into the modern state of Indiana.

One

Arrival and Establishment in Indiana

In 1840, the seeds that Bishop Simon Gabriel Bruté had sown in his European travels began to bear fruit. Although Bruté had died in 1839, his successor, Bishop Célestin de la Hallandiére, continued the search for assistance in Europe.

At first, the religious came slowly, a few sisters here, a few priests and brothers there, but with time there developed a steady flow of missionary groups arriving in the diocese to establish schools, clinics, and social service facilities.

As success became evident, the flow of Catholic religious into Indiana grew dramatically. In a few decades, the religious communities would serve in schools throughout the state, health care clinics were opened, and assistance was available for the poor and elderly.

Upon their arrival, the communities sought practical shelter: nothing of a formal nature, just a living space, a prayer space, and a place for the work of the ministry. However, these accommodations soon became inadequate, as the communities accepted local applicants, presenting a need for a novitiate or oblate program.

Thus dawned the second phase of the establishment of the religious communities, the construction of permanent facilities. These structures were designed to suit each community's particular needs for living and prayer spaces according to their rules, accommodations for oblate and novitiate programs, space for the training and education of their own members, and facilities required to perform their work. For a few, this meant the construction of a traditional monastery or convent, most often reminiscent of the European monasteries and convents from which they had come. For others, the construction was a school or hospital with an attached but separate home and chapel for the religious community.

Whatever the style, these structures not only served as working and living quarters but also created a sense of stability and permanence. The message and symbolism were clear: these religious communities were not here only to assist in the immediate needs, they were now an integral part of the society. Indiana had now become home.

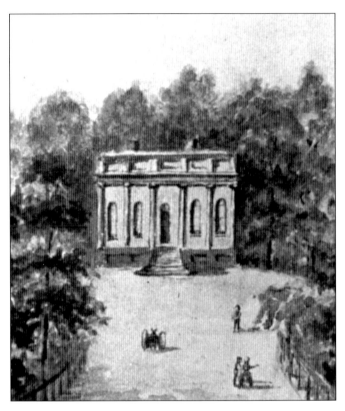

Led by St. Mother Theodore Guerin, the Sisters of Providence arrived at the village of St. Mary, near Terre Haute, on October 22, 1840. Upon their arrival, they were sheltered in the farm home of the Thralls family. They immediately undertook construction of St. Mary's Female Institute, seen in this early drawing by one of the sisters. It was known as "the academy," and the first students were accepted in July 1841. (Sisters of Providence, St. Mary of the Woods.)

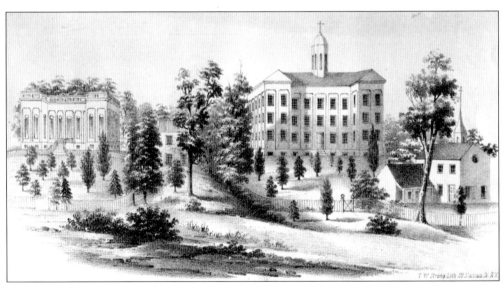

The academy met with immediate success and expansion of the facilities, including an enlarged school and a proper convent moved at a rapid pace. This drawing shows the buildings that existed prior to a fire in 1889 that destroyed the convent building. The efforts of the firefighters and the sisters were sufficient to prevent destruction of the church that was under construction at the time. (Sisters of Providence, St. Mary of the Woods.)

Saved from the ravages of the fire, the Church of the Immaculate Conception is today the centerpiece of a campus that is home to the Sisters of Providence in the United States and St. Mary of the Woods College. From this Indiana base, the sisters serve throughout the nation and world in a variety of educational and social service missions. (Sisters of Providence, St. Mary of the Woods.)

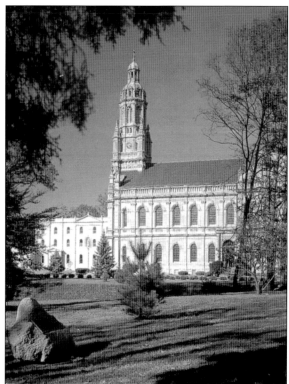

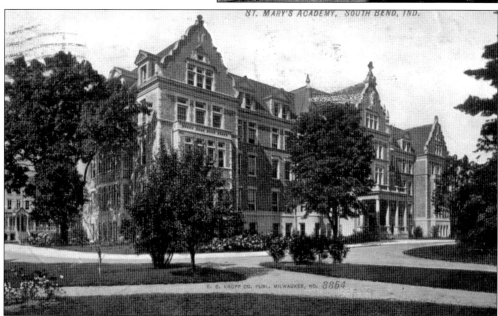

The early 1840s brought the Holy Cross priests, brothers, and sisters to the South Bend area. All eventually established institutions of higher education. Seen in this early photograph is the building constructed in 1902–1903 on Saint Mary's campus. At that time it housed Saint Mary's Academy and Saint Mary's College, both educational institutions for young women sponsored by the Sisters of the Holy Cross. (Sisters of the Holy Cross, Notre Dame.)

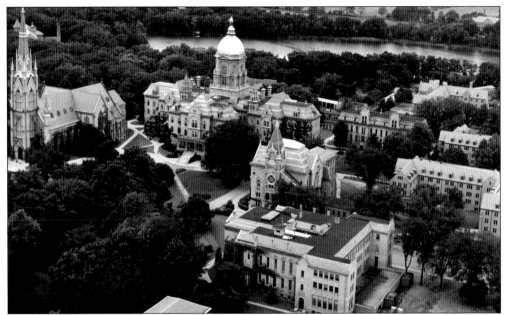

In 1841, the first Priests of Holy Cross and Brothers of Holy Cross arrived in South Bend to establish a boy's school. The school flourished and grew to become the University of Notre Dame. This aerial view of the central campus around 1955 gives a clear view of the dome of the administration building, likely the most widely recognized image of a Catholic institution in Indiana. (Priests of Holy Cross, Indiana Province Archives.)

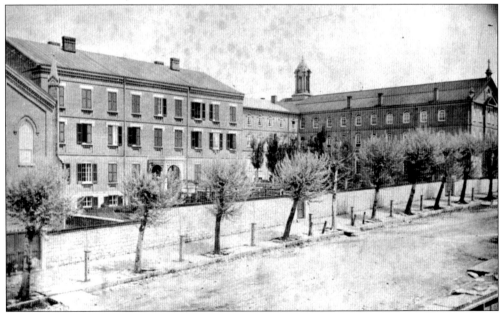

In January 1851, the first Sister of St. Francis arrived in Oldenburg to staff a school for the German-speaking children. Originally housed in a log cabin, a stone convent was built in 1852 and then expanded to include an academy. This photograph shows the buildings about 1880, which include the chapel (1858), the convent and academy (1857), and St. Cecilia Hall (1875). (Sisters of St. Francis, Oldenburg.)

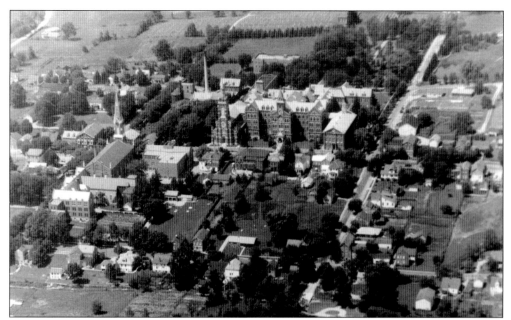

This 1956 photograph shows the results of a century of success and growth. The convent complex (center of photograph) is the dominant structure in the town of Oldenburg. It includes a flourishing academy for young ladies, the convent, the chapel, and the necessary office and administration space for the sisters who staff elementary and secondary schools and a college in central Indiana. (Sisters of St. Francis, Oldenburg.)

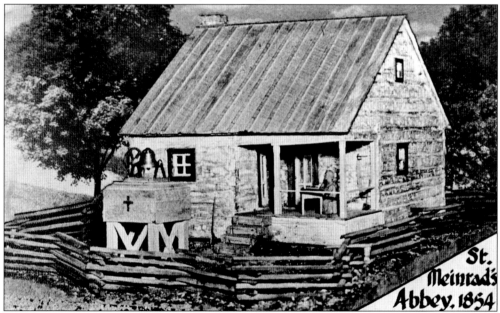

In the early 1850s, the Swiss Einsiedeln Abbey sent two Benedictine monks to southeastern Indiana to investigate the prospects of establishing a new abbey. A principal goal of this mission was to establish a seminary for the education of local candidates for the priesthood. On March 21, 1854, they established St. Meinrad Abbey, building a small wood cabin as seen in this drawing. (St. Meinrad Archabbey Archives.)

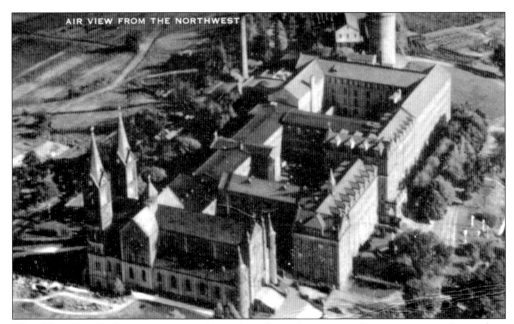

The abbey flourished, growing in numbers of monks and opening a 12-year seminary for resident students for the priesthood. The imposing sandstone buildings seen in this 1944 postcard replaced the wood cabin. The buildings (from bottom to top) include the church, the monastery proper, and a quadrangle of buildings that housed the seminary students. All were constructed of locally quarried stone and built by the monks and local craftsmen. (Authors' collection.)

This view of the archabbey church of Our Lady of Einsiedeln is the most familiar image of St. Meinrad Archabbey and is often referred to as "the heart of the archabbey." The church is of a cruciform design with east to west orientation, typical of 19th-century church architecture. The monks and area craftsmen constructed the church of local sandstone between 1899 and 1907. (Authors' collection.)

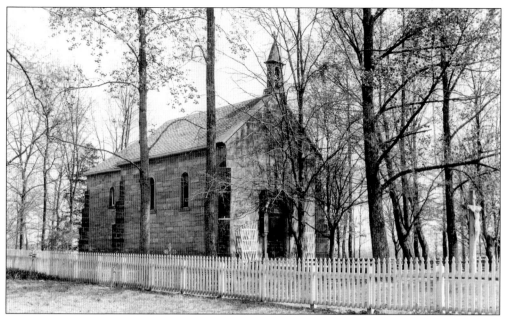

About a mile distant from the archabbey, on a hill with panoramic views of the Anderson Valley is the Shrine of Monte Cassino. The shrine, dedicated to the Blessed Virgin Mary, was constructed in 1870 of sandstone quarried from the same hill. Local history recounts that a novena to Our Lady of Monte Cassino is credited with saving the village of St. Meinrad from a smallpox epidemic in 1871. (St. Meinrad Archabbey Archives.)

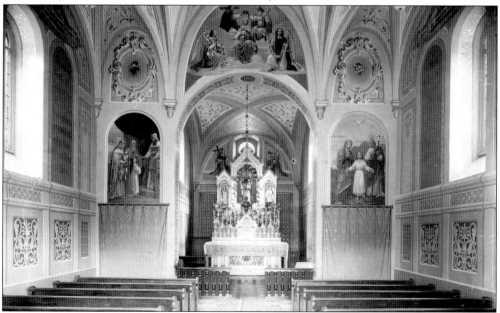

The interior of the Shrine of Monte Cassino is decorated with intricate artwork depicting scenes from the life of Mary along with symbolic representations of her titles as found in the litany to the Blessed Virgin. The faith that people place in the intersession of Mary in 1871 has not waned. The chapel is visited by hundreds of people every year offering prayers and petitions. (St. Meinrad Archabbey Archives.)

On August 20, 1867, four sisters from the Benedictine monastery at Covington, Kentucky, arrived at this small house in Ferdinand. They came in response to a request from the local pastor to teach the children in the German-speaking community. Two days after their arrival they received their first postulant and began to outgrow their small convent. (Sisters of St. Benedict, Ferdinand.)

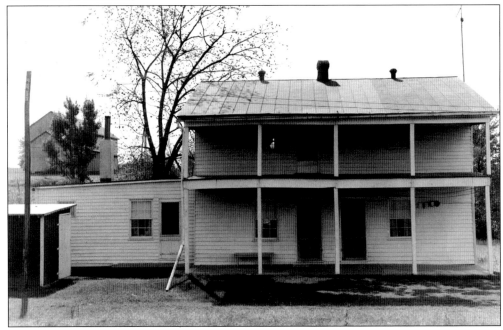

The original convent was enlarged over the years to accommodate the growing community until the sisters were able to construct a new monastery. After the sisters moved, a part of the original house continued to be used as a residence for nearly a century. This 1970 photograph shows the house just a few weeks before it was razed. (Sisters of St. Benedict, Ferdinand.)

16

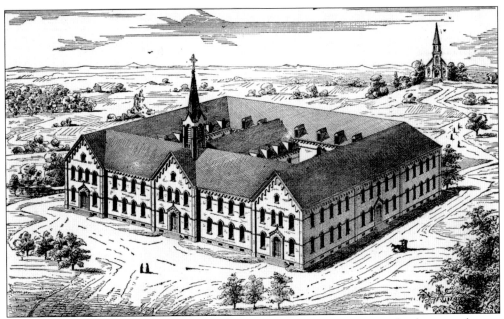

Within a few years it was evident that the growing community required a larger and more permanent monastery. Land was acquired on a hill overlooking the town, and local craftsmen undertook the construction of a redbrick quadrangle for the monastery itself, with the church contained in a center leg as shown on the architect's original drawing. The sisters moved into this new monastery in 1886. (Sisters of St. Benedict, Ferdinand.)

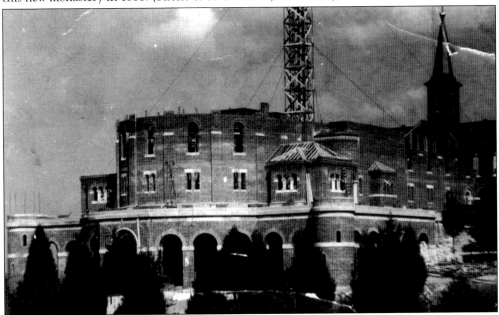

By the early 1900s, the growing community needed to expand once again. In 1915, construction began on a new church to be attached to the front of the existing monastery. The exterior of the new building was completed in 1916, but World War I caused construction to be temporarily halted. After the war the craftsmen returned to complete the project, and the new church was dedicated in 1924. (Sisters of St. Benedict, Ferdinand.)

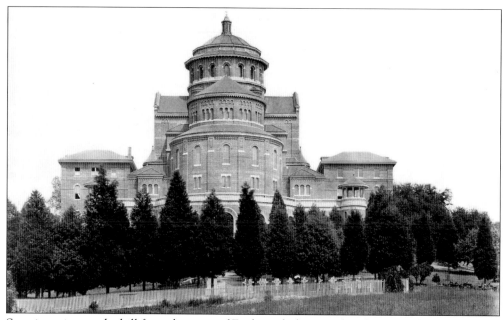

Seen in a view up the hill from the town of Ferdinand, the new church is now the predominant feature of Monastery Immaculate Conception, often referred to as "the Castle on the Hill." Over nearly 125 years, the facility has housed the sisters, provided administration space for their extensive missions in education and health care, and for many years was home to an academy and a college. (Sisters of St. Benedict, Ferdinand.)

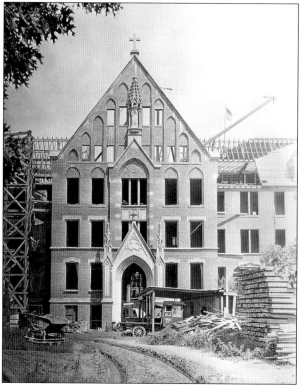

In August 1868, eight sisters of the Poor Handmaids of Jesus Christ arrived in Hessen Cassel, near Fort Wayne. They immediately took charge of the parish school and began nursing the sick in the area. With success in their missions came growth, so a new motherhouse for the American province seen here under construction in 1920 was located in Donaldson. (Poor Handmaids of Jesus Christ.)

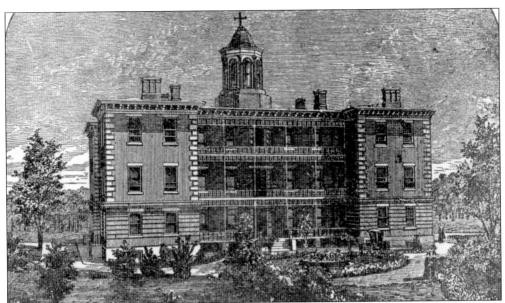

On the feast of St. Vincent in 1872, the Daughters of Charity opened the doors at the first St. Mary's Hospital in Evansville. This postcard view shows the newly opened hospital located in a building that had originally been the Marine Hospital at Tenth and Wabash Streets. Local business leaders, seeing the need for a medical facility, had acquired the abandoned hospital building and provided it to the sisters to serve the community. (Daughters of Charity Archives, Evansville.)

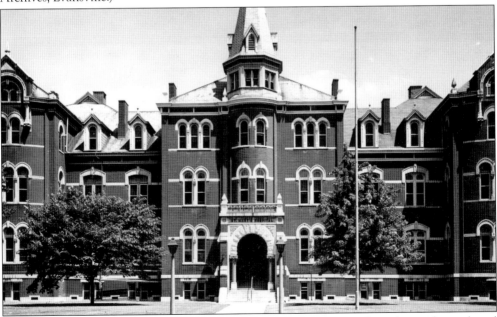

As was the norm for the missions of the religious communities, success brought rapid growth and the need to improve and expand. The sisters began fund-raising for a new hospital and broke ground for this new and modern facility on First Avenue in 1893. This facility would be home to St. Mary's Hospital until a new hospital was constructed on Washington Avenue in the 1950s. (St. Mary's Medical Center Archives, Evansville.)

By 1873, Indianapolis, the state capital, was becoming a major urban center of business, industry, and transportation. A byproduct of that growth was a sizable population of indigent elderly residents who were in need of shelter and care. At the invitation of Bishop Maurice de St. Palais, the Little Sisters of the Poor came to Indianapolis to open a home for the poor and elderly of the city. The first home (above) was built on East Vermont Street, near downtown, and through several additions and renovations the sisters served the central city for 90 years. Eventually the building became too expensive to repair and maintain to meet modern building codes, so funds were raised for the construction of a new home on the city's north side. The present St. Augustine Home (below) was built in 1964–1965, and there the sisters continue to serve the poor and elderly of central Indiana. (Archdiocese of Indianapolis Archives.)

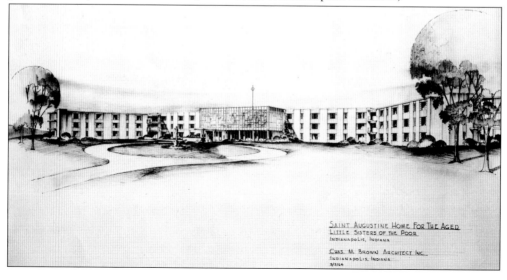

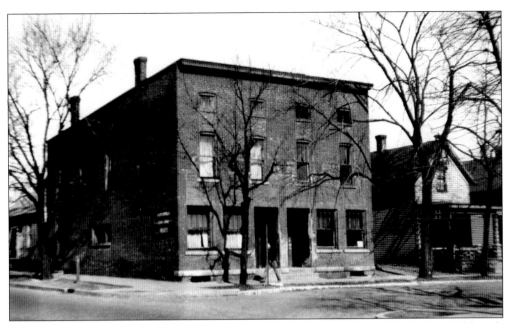

In 1875, a group of Sisters of St. Francis arrived in Lafayette to open a medical clinic. Although this event marks the founding of St. Elizabeth Hospital, the first building could hardly be deemed more than an infirmary. Seen here in an 1882 photograph, the storefront structure (still standing at Sixteenth and Cincinnati Streets in Lafayette) housed the sisters and their clinic until a proper hospital could be constructed. (Sisters of St. Francis, Mishawaka.)

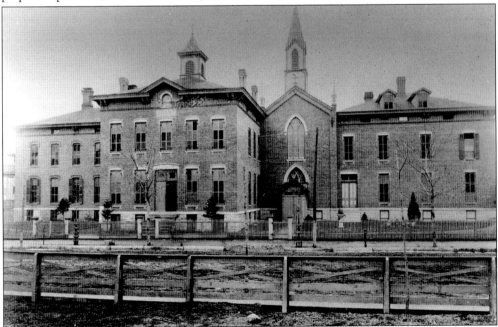

In the late 1880s, the sisters were able to build the first St. Elizabeth Hospital. Seen here in a 1900 photograph, the original hospital building had already been expanded twice by adding wings on the east and west sides. The building housed not only the hospital but also a nursing school and the convent for the sisters. (Sisters of St. Francis, Mishawaka.)

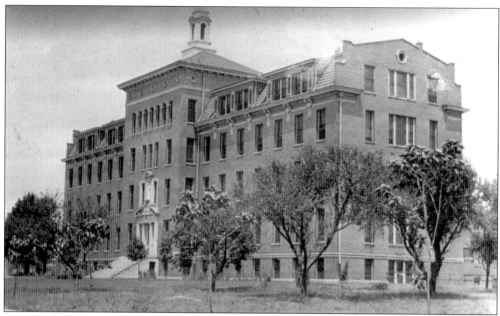

In 1913, the Sisters of St. Francis took their hospital mission to Beech Grove, a small town on the southeast edge of Indianapolis, and established St. Francis Hospital. The original building shown here has been expanded numerous times and eventually became the namesake hospital of the Sisters of St. Francis Health Services. The present healthcare system includes hospitals, medical offices, and clinics around the state. (Sisters of St. Francis, Mishawaka.)

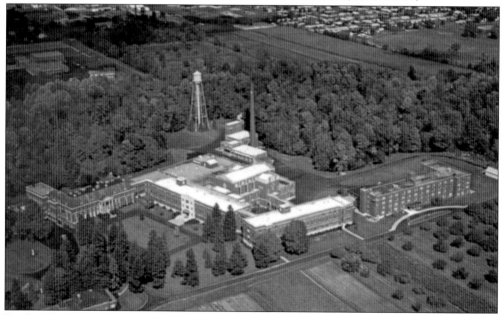

By the 1940s, space at St. Elizabeth had reached its limits. The hospital and nursing school had grown, and the sisters' own ranks were increasing. Further expansion at St. Elizabeth was impractical, so the sisters relocated their convent to Mishawaka. Several expansions have created the modern convent seen in this aerial photograph. The Sisters of St. Francis Health Services offices are also located on this site. (Sisters of St. Francis, Mishawaka.)

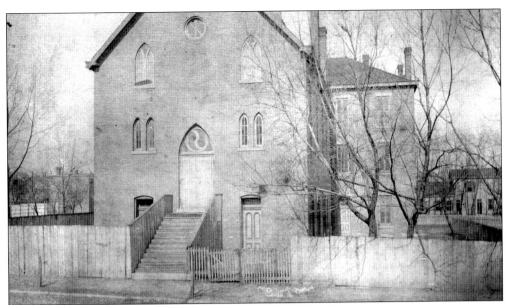

By 1880, the growing city of Indianapolis was encountering a flood of new immigrants, many Catholic, and faced a dire shortage of healthcare services. Bishop Silas Chatard searched for a religious community to open a clinic in the city. On April 27, 1881, four Daughters of Charity opened an infirmary named for St. Vincent in this small building on East Vermont Street near downtown. Thus began the present St. Vincent Health organization. (St. Vincent Hospital Archives, Indianapolis.)

The Daughters of Charity's first expansion was the construction of a four-story hospital in the wholesale and industrial district at South and Delaware Streets. A 1904 fire in a neighboring factory provided the impetus to construct a new hospital away from the downtown area. This 1940 postcard view shows the building begun in 1910 at Fall Creek Boulevard and Illinois Street that served the city until 1974, when St. Vincent moved to a new facility on West Eighty-sixth Street, where it remains today. (Authors' collection.)

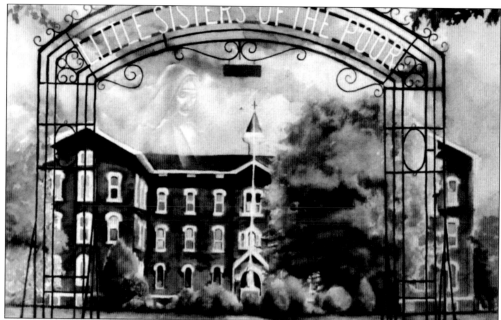

In April 1882, the Little Sisters of the Poor arrived in Evansville to take possession of a large home on Stringtown Road that had been provided by a local benefactor. The sisters immediately began taking in elderly and infirm residents, and within two years they were outgrowing the building. By February 1884, they had 20 residents in the home. That same year the Reitz family donated land on Lincoln Avenue and paid much of the cost to construct a much larger brick structure to house the sisters and their residents. The home on Lincoln Avenue opened on July 12, 1887, (above) and with some modernization and expansion served the sisters and their residents until 1971. The original home was demolished to complete the renovation of St. John Home for the Aged into the modern home that occupies the Lincoln Avenue property today (below). (Little Sisters of the Poor, Evansville.)

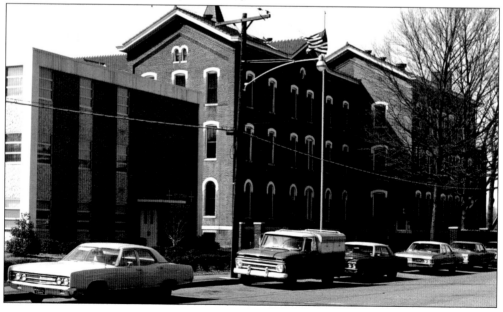

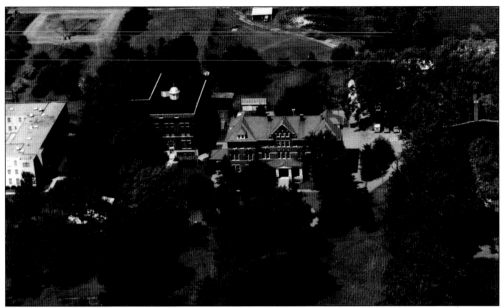

The Sisters of St. Joseph arrived in Tipton in 1888 at the invitation of the local pastor. They established St. Joseph Hospital at Kokomo in 1913. The sisters acquired land and constructed a motherhouse that opened in 1891. The aerial photograph (above) shows the original motherhouse in the center with additions and a gymnasium that had been added over the years. As the buildings aged, the costs of maintenance and repair, along with the changing nature of the community's missions, dictated that major modernization be undertaken. The sisters elected to construct a new modern motherhouse adjacent to the original complex (seen at the far left of photograph above and in photograph below) that serves the sisters today. All the original buildings except the gymnasium have been razed since the new building was opened. (Sisters of St. Joseph, Tipton.)

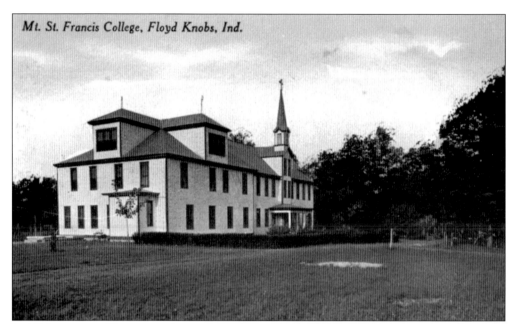

Mt. St. Francis College, Floyd Knobs, Ind.

In 1896, a group of Franciscan friars acquired a tract of land near Floyd Knobs. They named the location Mount St. Francis and laid plans to open a school for boys as well as a seminary. This 1913 postcard is a view of the original building that had already undergone a major expansion in 1910. The building housed the friars and their students and included a chapel and classroom spaces. (Friars of St. Francis, Mount St. Francis.)

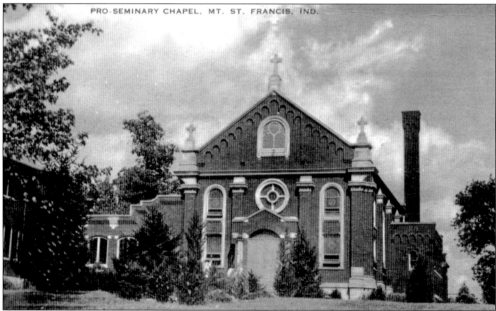

PRO-SEMINARY CHAPEL, MT. ST. FRANCIS, IND.

This 1940 postcard shows the brick chapel that was constructed in 1925. By this time, the friary included a seminary and farming operation that provided much of the food for the friars and students. Today the property still is home to a number of friars who serve in the local area, operate a retreat house, and are heavily involved in Catholic youth ministries. (Friars of St. Francis, Mount St. Francis.)

In 1897, a group of sisters of the Order of St. Clare, generally known as the "Poor Clares," arrived in Evansville to establish a monastery. The Poor Clares were different from the religious communities that had preceded them into Indiana. They had not come to operate schools, health facilities, or social services but rather to serve the church itself. As a contemplative community, their lives would be spent within the confines of the monastery, serving the church and society first in prayer and then in the provision of material goods for the church. The sisters made vestments and altar goods, baked Eucharistic wafers for the local parishes, and provided similar services that could be done within the confines of the monastery. Their first monastery (above) that opened in 1897 served the community until 1984 when a new, more modern convent (below) was built away from the downtown area. (Poor Clares, Evansville.)

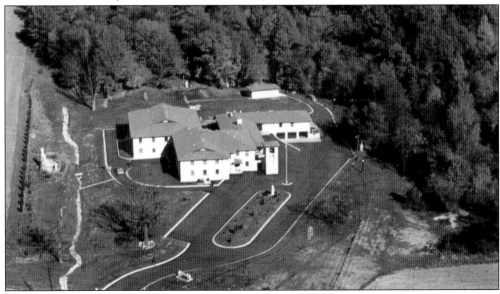

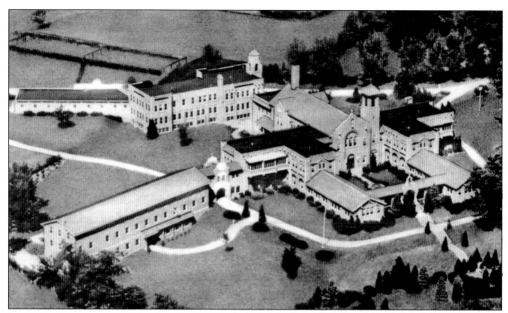

In 1922, the maturity of the church in Indiana was illustrated by the founding of a new religious community that would reside near Fort Wayne. Under the auspices of Bishop John F. Noll, the Our Lady of Victory Missionary Sisters was formed to provide missionary catechists to the western United States. The convent and motherhouse, known as Victory Noll, at Huntington is seen in this aerial view. (Our Lady of Victory Missionary Sisters Archives.)

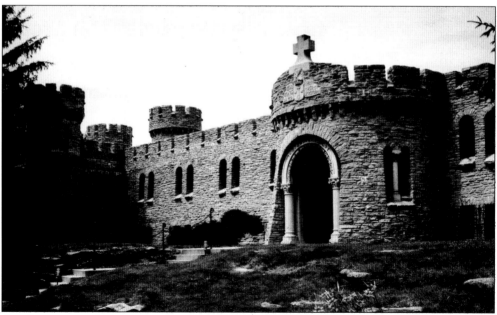

Another contemplative order, the Carmelite Sisters, arrived in Indianapolis in 1932. They constructed a new monastery, referred to as a "Carmel," with a unique stone architecture in the style of a castle enclosed by a wall. The construction was completed in various stages over a period of 21 years. The Carmel served the sisters until dwindling membership resulted in closure in 2006. (Archdiocese of Indianapolis Archives.)

In 1947, a group of sisters from the Indianapolis Carmel relocated to Terre Haute to form a new community to serve the church in the western part of the Archdiocese of Indianapolis. Unlike the walled enclosure style of the Indianapolis Carmel from which they had come, the new monastery is a modern brick-and-glass structure located in a peaceful wooded setting. (Archdiocese of Indianapolis Archives.)

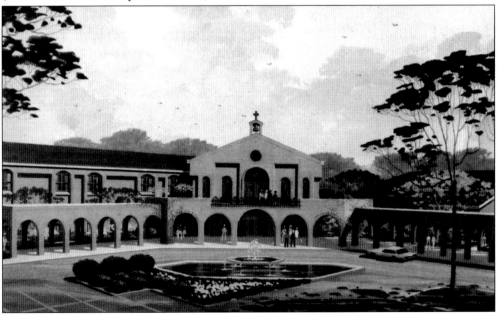

In the northwest corner of the state, the available industrial work in the steel and manufacturing industries had drawn a large influx of eastern European immigrants. Following World War II, a group of Carmelite priests came from Poland to serve that community. They established a monastery (architect's concept drawing above) and shrine at Munster, serve at regional parishes, and host many Polish ethnic celebrations. (Carmelite Fathers, Munster.)

At the request of Archbishop Schulte, the Sisters of St. Benedict at Ferdinand sent six sisters to Beech Grove in 1955 to establish a monastery that would include an academy and a retirement home. Located on the northwest edge of Beech Grove, Our Lady of Grace Monastery operates St. Paul Hermitage and the Benedict Inn Retreat and Conference Center. The sisters also serve the community in a number of educational and social missions. (Sisters of St. Benedict, Beech Grove.)

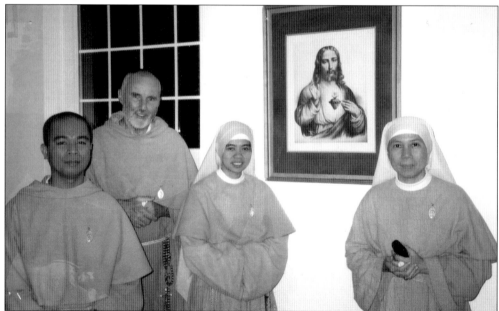

Upon entering the 21st century, the general conception may be that the missionary work in Indiana is done, but new religious communities continue to arrive to serve in ways that were not addressed by the early pioneers in education and healthcare. The Franciscan Friars and Sisters of the Immaculate arrived in Bloomington in 2005–2007 to establish a friary and convent at Mother of the Redeemer Retreat Center. (Franciscan Friars of the Immaculate, Bloomington.)

Two

HEALTHCARE AND THE DIGNITY OF LIFE

Thinking of healthcare in Indiana, the names of various Catholic-affiliated hospitals and medical services are sure to come to mind. The Sisters of St. Francis of Perpetual Adoration in Mishawaka sponsor the Sisters of St. Francis Health Services, caretakers of the large and respected Indianapolis healthcare ministries of St. Francis Hospital and Health Services (established in 1913), as well as numerous smaller facilities including St. Clare Medical Center in Crawfordsville, St. Margaret Mercy Healthcare Center in Hammond, St. Elizabeth Regional Health and St. Elizabeth Medical Center in Lafayette, St. James Hospital and Health Centers in the Chicago area, and multiple health service operations. The Daughters of Charity support St. Vincent Health, including St. Vincent Indianapolis Hospital (established in 1881), as well as St. Joseph Hospital in Kokomo, St. Mary's Hospital and Health Services in Evansville, and Providence Hospital and Medical Center in Michigan, among numerous other facilities. The Poor Handmaids of Jesus Christ had invested many resources toward the provision of healthcare but divested their hospital ministries in recent years, including St. Joseph's Hospital in Mishawaka and Holy Family Hospital in LaPorte; the Poor Handmaids still maintain a presence in the several communities once served by their health facilities.

If not directly involved with hospital sponsorship and administration, the members of Indiana's religious communities can be found as auxiliary service providers, providing direct care to the sick and infirm, volunteering their time and expertise. Many orders have operated or currently operate homes for the aging, sanitariums, hospice and home services, substance abuse ministries, and associated wellness missions.

Picture the following: a Little Sister of the Poor holds the hand of an ailing resident during the sacrament of last rites administered at St. Augustine Home in Indianapolis; a Sister of Providence works with AIDS patients at a community health clinic; a Sister of St. Joseph comforts the parents of an injured child. Many people have been touched by the members of Indiana's Catholic communities in times of joy, through the pain of illness, the celebration of recovery, fears of aging, and the final moments of life.

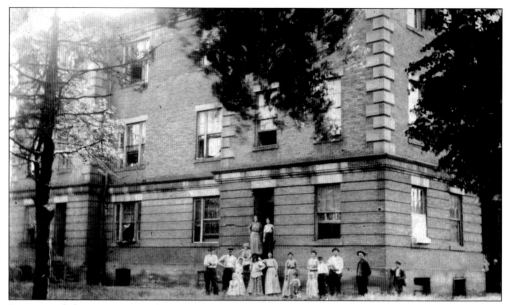

Because of the growing medical needs of the people of Evansville, the Daughters of Charity were invited by Catholic leadership to assist with the development of healthcare services in this increasingly populous riverfront city. Seen here is the original St. Mary's Hospital building located near the Ohio River. This modest building was often overcrowded, but the sisters never refused services to anyone regardless of their ability to pay. (St. Mary's Medical Center Archives, Evansville.)

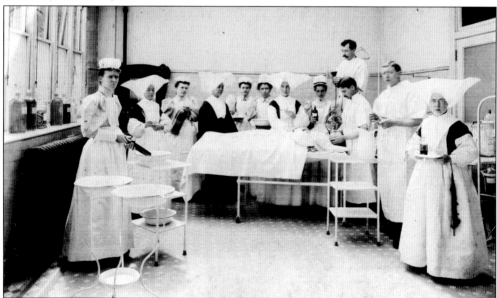

St. Mary's Hospital was innovative from the very beginning. Seen here is the main surgical operating room at the First Avenue hospital as it appeared in the 1900s. Note the number of dedicated healthcare personnel needed for even routine procedures. The physician is in the far upper right corner. Operating rooms were crowded during room preparation and actual procedures. Platforms were used to improve visibility. (St. Mary's Medical Center Archives, Evansville.)

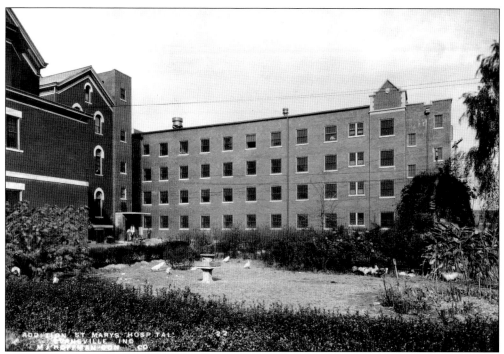

Word-of-mouth testimonials brought more and more patients through the doors of St. Mary's Hospital. Because of ever-increasing demand and cramped facilities, the hospital expanded with a new addition, as seen in 1923. The founding sisters would be amazed that St. Mary's Medical Center today includes multiple locations in Evansville as well as facilities in Boonville and Newburgh. (St. Mary's Medical Center Archives, Evansville.)

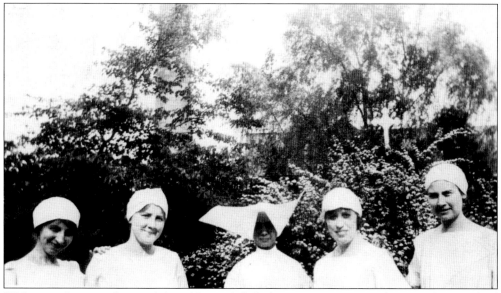

With growth came the need for additional skilled caregivers. During this period in medical history, the responsibility to train nursing students rested with each individual hospital. These nursing students are learning the importance of patient care during a nurse training session at St. Mary's Hospital in 1924. (St. Mary's Medical Center Archives, Evansville.)

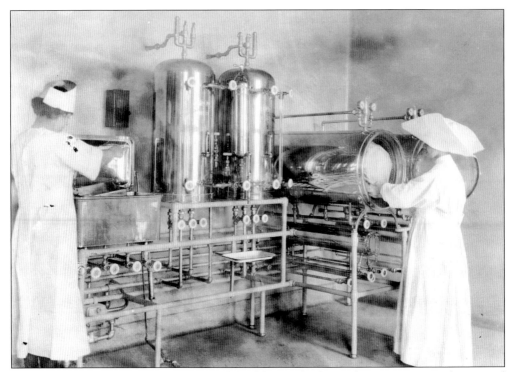

Even in the early years of institutional healthcare, both costly sanitation machines and state-of-the-art medical equipment were needed. The prevention of new infections, containment of illnesses, and minimization of reinfection were always priorities in the sterilization room at St. Mary's around 1925. Specialized machines and trained attendants ensured that proper procedures were followed (above). A common sight at St. Mary's and other hospitals in the 1930s were oxygen tents. Patients thought to be infectious or those in respiratory distress were often found beneath the tents (below). (St. Mary's Medical Center Archives, Evansville.)

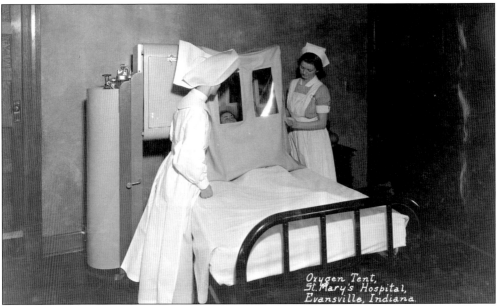

Oxygen Tent,
St. Mary's Hospital,
Evansville, Indiana.

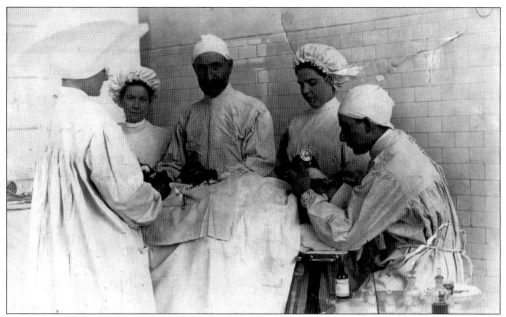

Dr. Herman Baker (seated) begins a detailed surgical procedure in one of the many operating rooms at St. Mary's Hospital around 1940; a Daughter of Charity is present to assist with the procedure. The Daughters of Charity founded, administered, and financially supported St. Mary's, as well as actively participated in the direct provision of services and patient care. (St. Mary's Medical Center Archives, Evansville.)

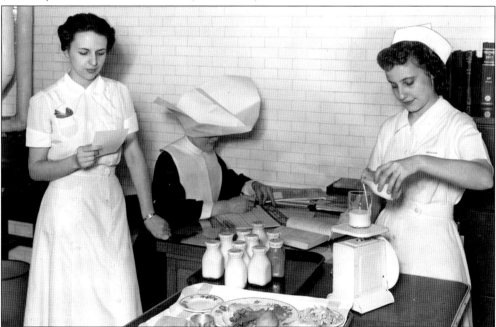

The 1940s brought a heightened awareness of the nutritional and dietary needs of the patients. This 1948 photograph taken in the St. Mary's Hospital kitchen shows the staff dietician instructing a student nurse on the basics of meal preparation. Dietary supervisor Sister Louise Rother is charting notes in the background. (St. Mary's Medical Center Archives, Evansville.)

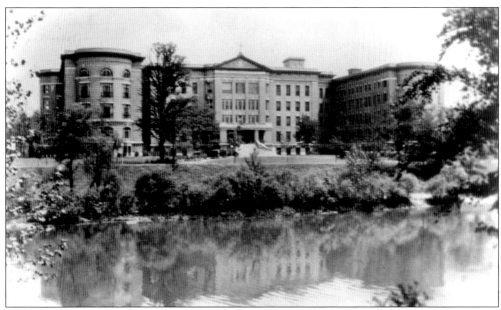

In 1878, Bishop Francis Silas Chatard was called to establish and promote a new hospital for residents of Indianapolis; he chose the Daughters of Charity to operate the facility. In February 1913, St. Vincent Hospital moved into its third home on wooded land north of the banks of Fall Creek between Capitol Avenue and Illinois Street. Depicted here is St. Vincent Hospital's 385-bed and 58 bassinet home for the next 61 years. (Daughters of Charity Archives, Evansville.)

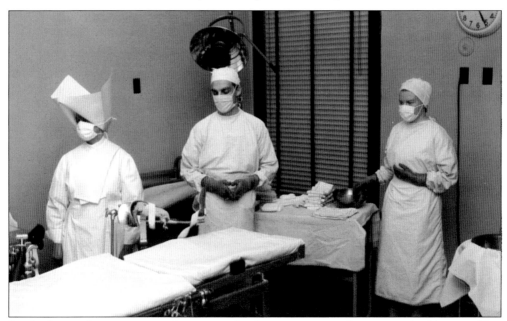

In the hospital's previous two locations, the first in an unused seminary building on East Vermont Street and the second at South and Delaware Streets, advanced surgery was difficult. The facilities were little more than infirmaries. In 1911, just prior to the move to the banks of Fall Creek, the legal name of the infirmary was changed to St. Vincent Hospital. Seen here is an operating room around 1915. (St. Vincent Hospital Archives, Indianapolis.)

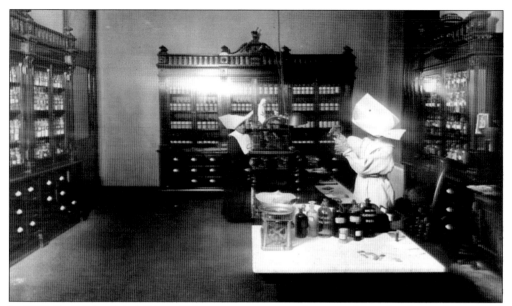

In 1925, Sr. Editha Fairchild could be seen mixing together ingredients for the medicines used at St. Vincent Hospital. Hospital pharmacies and family physicians' offices were the primary sources for medication during this time. Working in the hospital pharmacy demanded specialized knowledge. Many medications of the era were either very expensive or simply not commercially available, so compounding in the hospital pharmacy was the normal practice. (St. Vincent Hospital Archives, Indianapolis.)

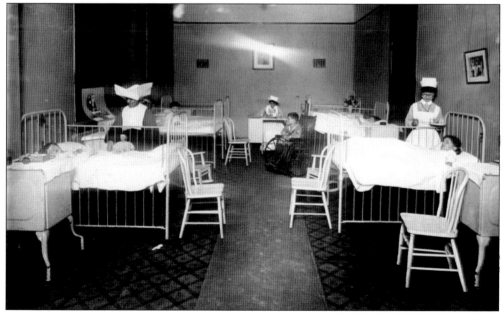

St. Vincent Hospital was one of the first Indiana hospitals with an exclusive ward dedicated to pediatric services, as pictured here in the 1940s. The hospital later opened an entire facility catering to ill children. Recently the facility transformed into the Peyton Manning Children's Hospital, named after the successful Indianapolis Colts quarterback. (St. Vincent Hospital Archives, Indianapolis.)

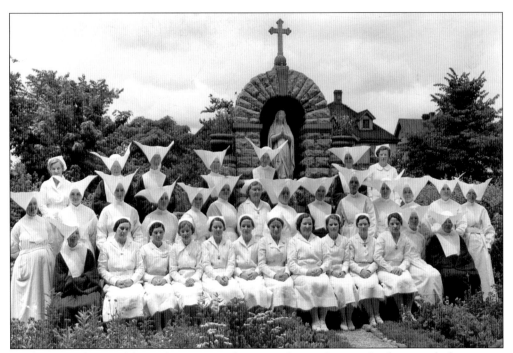

It takes many hours of focused training to become a hospital nurse. In the years before nurses were trained in colleges and universities, students were indoctrinated into their medical careers through hands-on and on-the-job training techniques. Seen above is a 1940s nursing class at St. Vincent Hospital. Because the study of nursing is such a demanding career choice, the Daughters of Charity would conduct elaborate capping ceremonies to celebrate the success of new graduates. Two Daughters of Charity formally recognize their students' rite of passage into the nursing field during this 1950s event (below). (Above, St. Vincent Hospital Archives, Indianapolis; below, Archdiocese of Indianapolis Archives.)

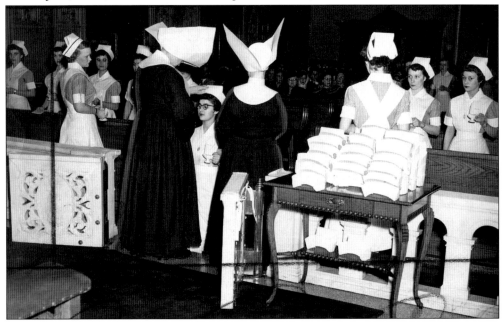

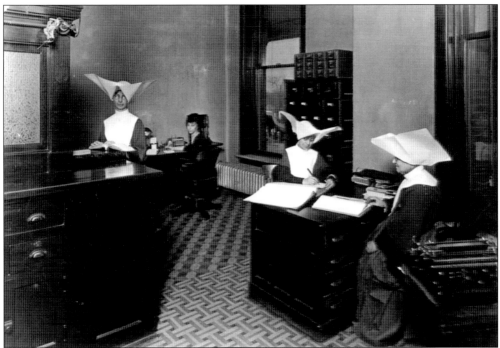

Aside from the direct provision of healthcare, many auxiliary and administrative duties were required within the hospital setting. While many citizens viewed hospitals with distrust, fearing the facilities as houses of disease that bred illness, hospitals were eventually welcomed by communities not only for their medical success stories but also for their creation of employment and economic benefits. Depicted here are the office area (above) and kitchen (below) at St. Vincent Hospital during the 1930s. Note that the Daughters of Charity are working side by side with lay workers. The Daughters of Charity were known for their hands-on supervision in nearly every aspect of hospital operations. (St. Vincent Hospital Archives, Indianapolis.)

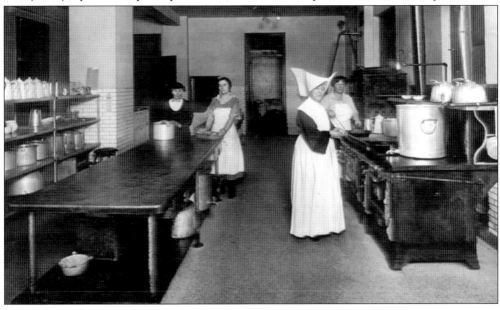

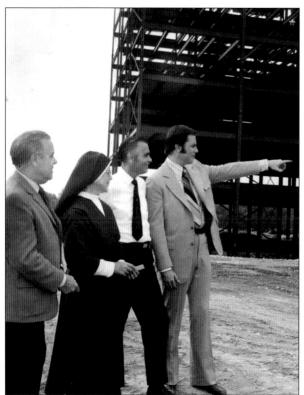

By the 1960s, overcrowding and the need to renovate an aging facility were issues the Daughters of Charity frequently confronted. Land was purchased between Ditch Road and Township Line Road along Eighty-sixth Street on the northwest side of Indianapolis. Ground was broken for the new facility on January 4, 1971, and construction immediately followed. At left, hospital administrators and a sister survey the initial phase of hospital construction. On March 31, 1974, the Daughters of Charity moved into their fourth home (below); the move took only 3 hours and 20 minutes to complete. It is awe-inspiring to note that in 1881 four Daughters of Charity began with less than $100 between them and built St. Vincent Hospital into one of the largest and most complete healthcare systems in Indiana. (Archdiocese of Indianapolis Archives.)

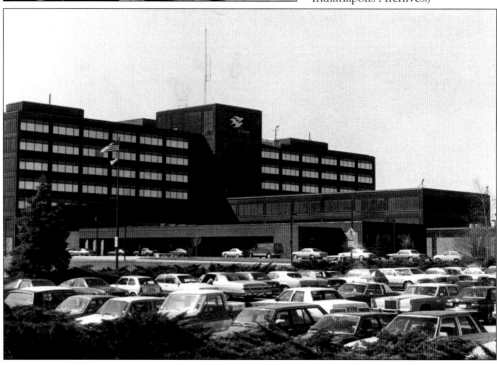

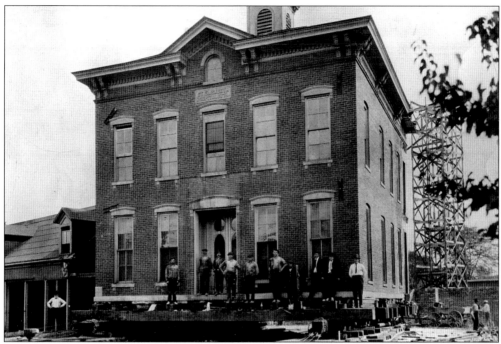

Along with the Daughters of Charity, the Sisters of St. Francis of Perpetual Adoration in Mishawaka are sponsors of a large Indiana network of healthcare facilities known as the Sisters of St. Francis Health Services. St. Elizabeth Medical Center had humble beginnings in 1876 when six Sisters of St. Francis were called to leave their home in Germany to provide healthcare in Lafayette. Pictured here is the sisters' first home and hospital, a converted storefront, as it stood in 1921 prior to being moved (below) as well as during the actual move (above). Known originally as St. Elizabeth's Hospital, the sisters outgrew their space and needed more land, prompting the move of the convent itself to Mishawaka. (Sisters of St. Francis, Mishawaka.)

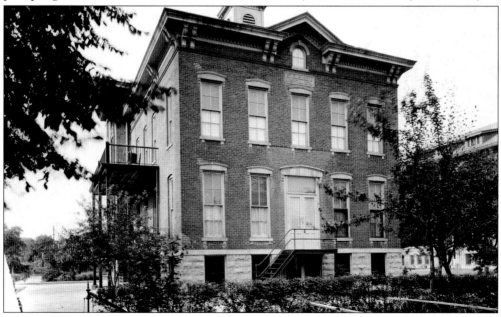

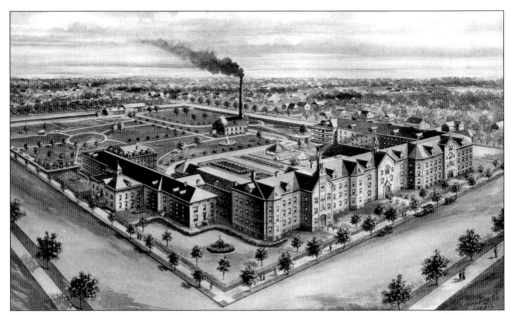

St. Elizabeth Hospital grew quickly in the early years, as seen in this unknown artist's depiction of the buildings and grounds. Current plans call for the original St. Elizabeth Hospital to be closed and replaced by a new facility in late 2009. It is hoped that the existing buildings and grounds will find new uses. (Sisters of St. Francis, Mishawaka.)

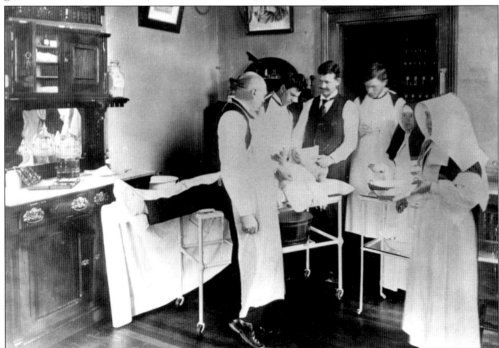

When the new St. Elizabeth Medical Center opens it will include eight operating rooms. While the new facility will certainly be state of the art and feature several amenities, patients will still need a doctor, nurses, and an operating table. This photograph shows an early surgical area at St. Elizabeth Hospital. (Sisters of St. Francis, Mishawaka.)

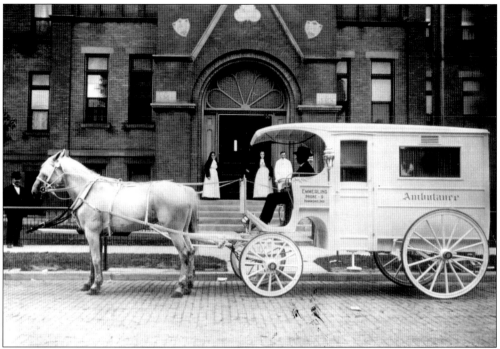

An ambulance waits outside the doors of St. Margaret Hospital in Hammond. Originally founded by the Sisters of St. Francis in 1898, the hospital merged with Our Lady of Mercy Hospital in Dyer. The two hospitals exist as two distinct campuses today and form the St. Margaret Mercy Healthcare Center. (Sisters of St. Francis, Mishawaka.)

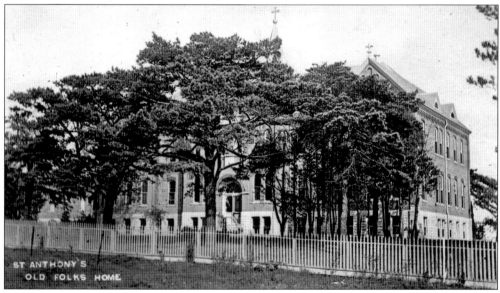

The sisters did not confine their healthcare ministry to hospitals. Seen in this 1902 photograph, St. Anthony Old Folks Home represented another extension of the sisters' care. Unlike the earlier time when people lived out their lives on the farm, the urban industrial centers were experiencing a rise in the numbers of people too old to work in the factories and in need of housing and care. (Sisters of St. Francis, Mishawaka.)

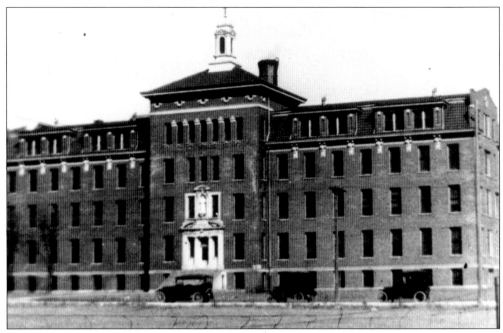

Invited by Rev. Francis Gavick to develop a hospital in Beech Grove in 1909, the Sisters of St. Francis acquired five acres of land for $1,000 at the corner of the present Troy Avenue and Sherman Drive. Dedicated on July 5, 1914, St. Francis Hospital treated 63 patients during its first year of operation. This image of the hospital was taken in 1927. (Beech Grove Public Library.)

Popular long-term St. Francis Hospital administrator Sister Alexis is seen during a Beech Grove community meeting at the hospital in 1940. Not one to stay in her office, Sister Alexis was known for her cheery demeanor and friendliness as well as her ability to get projects moving and get the job done. (Beech Grove Public Library.)

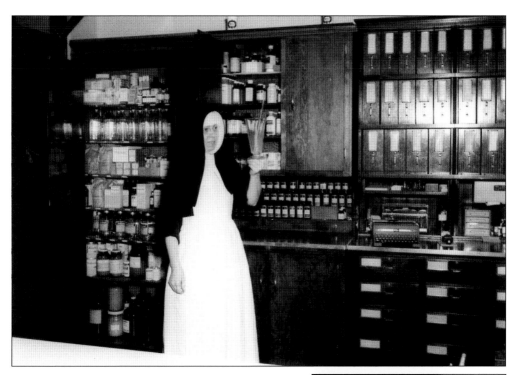

Quality care does not happen without people. Of the many familiar faces at St. Francis Hospital during the 1930s, two hardworking and caring individuals are fondly remembered for their tireless work to serve the sick and dying. Senior pharmacist Sister Cosma is seen working in the hospital pharmacy around 1935 as she prepares to mix an elixir (above). Beloved hospital chaplain Father O'Keefe is seen on one of his frequent walks through the hospital hallways, always carrying his flashlight, to visit and comfort patients during the summer of 1939 (right). St. Francis was known to have little staff turnover under the leadership of Sister Alexis. (Beech Grove Public Library.)

This rare photograph of Mother Maria Theresia Bonzel was taken in the late 1800s (left). Mother Bonzel founded the Sisters of St. Francis of Perpetual Adoration in Germany in 1863. Through the work of her sisters, healthcare in Indiana prospered. St. Francis Hospital continued to grow and develop several additions over the years, including this addition to Bonzel Towers photographed under construction in 1983 (below). As hospitals and health networks expanded in Indiana, so did the Sisters of St. Francis Health Services. Primary facilities now include St. Elizabeth (Lafayette); St. Clare (Crawfordsville); St. Anthony (Michigan City); St. Anthony (Crown Point); St. Margaret Mercy (Hammond and Dyer); St. James (Chicago area); and St. Francis (Beech Grove). Several additional healthcare facilities operate within each network. (Beech Grove Public Library.)

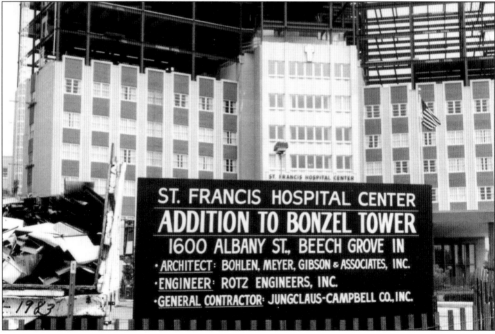

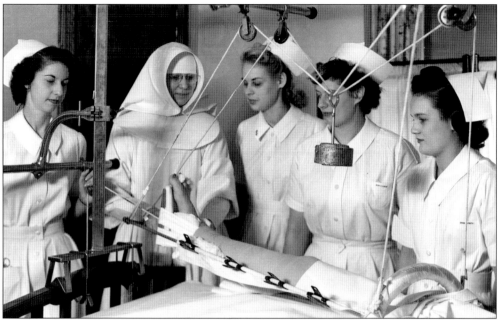

Throughout their existence in Indiana, the Poor Handmaids of Jesus Christ have been directly and indirectly involved in the provision of healthcare and medical outreach. Although the Poor Handmaids no longer sponsor any hospitals, they have a rich tradition of service to the sick and dying. In an undated photograph taken at St. Elizabeth Hospital in Chicago (above), a Poor Handmaid teaches students at the facility's nursing school; the sisters' involvement with St. Elizabeth Hospital dates back to 1887. The Poor Handmaids also sponsored St. Anne Hospital in Chicago from 1903 to 1989. This 1928 photograph shows the dedication of a new section of the hospital drawing a large crowd and fanfare (below). The Poor Handmaids' last hospital holding, St. Mary Hospital in East St. Louis, Illinois, was sold in 2004. (Poor Handmaids of Jesus Christ.)

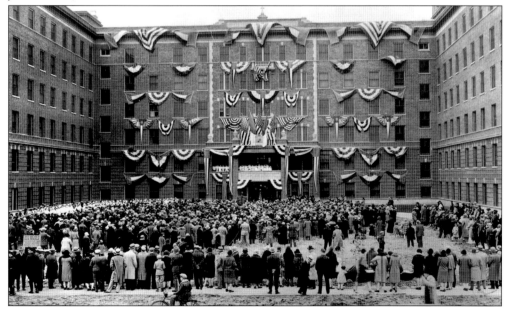

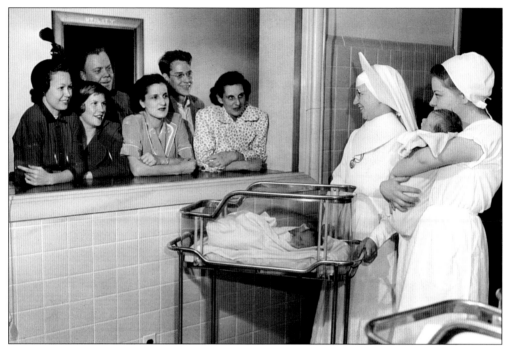

In 1874, the Sisters of the Holy Cross established and began operations of St. John's Hospital in Anderson. Pictured is maternity nurse Sister Mary Clarissa discussing medical issues with a family and calming the excitement associated with a new arrival. Sponsorship of St. Anthony's was transferred to the Daughters of Charity in 2004. (Sisters of the Holy Cross, Notre Dame.)

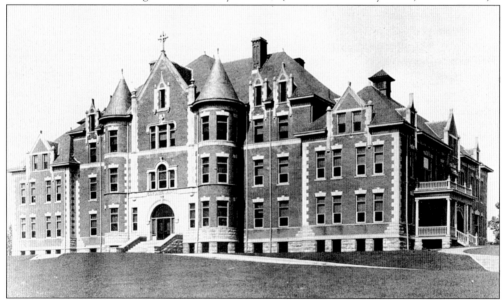

The Sisters of the Holy Cross founded St. Joseph Hospital in 1882 as the first healthcare facility in South Bend. Through the years there have been several expansions. The building in this photograph was constructed in 1903. The hospital is part of Trinity Health, which was formed in 2000 by Holy Cross Health System and Mercy Health Services. (Sisters of the Holy Cross, Notre Dame.)

In 1951, the Benedictine sisters at Monastery Immaculate Conception accepted the call to operate Stork Memorial Hospital in Huntingburg. In 1966, they began construction of a new facility and renamed it St. Joseph Hospital (above). After 38 years of successful operation, the sisters sold the hospital to direct their attentions elsewhere. Most of the Indiana Catholic religious communities have had some level of involvement in healthcare provision, including hospitals, clinics, and educational programs. Over time some work has been passed to lay administrators and staff. But aside from the overarching efforts of the sisters to run hospitals, the greatest personal fulfillment frequently arises from individual patient care. Sr. Gemma Gettlefinger assists Sr. Estelle Knapp with dialysis in the monastery infirmary (below). (Sisters of St. Benedict, Ferdinand.)

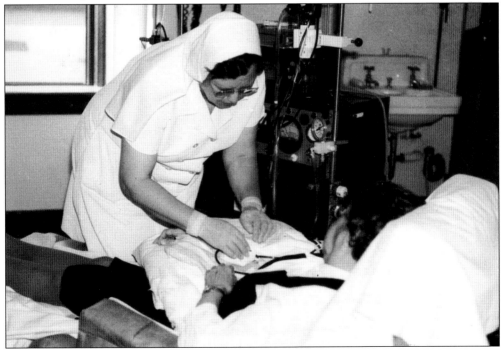

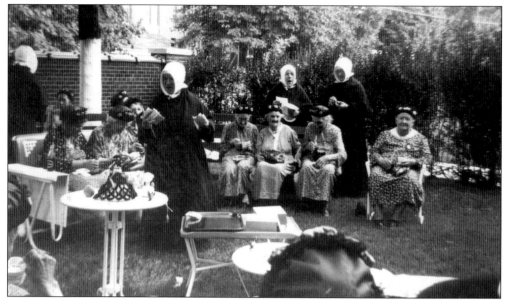

Not all healthcare services are provided in hospitals. The Little Sisters of the Poor operate the St. John Home for the Elderly in Evansville. The sisters' primary purpose is to provide for the poorest of the poor. Great care is taken to make the aging residents of the home feel like they are spending their last days with loving family. Residents enjoy a garden party in 1956 (above), and a sister assists in getting a corsage correctly placed (below). There are few early pictures of the ministries conducted by the Little Sisters of the Poor since cameras and film were expensive commodities. The sisters do not seek individual recognition for their work, and histories seldom refer to a sister by name—they prefer to be remembered only as a "Little Sister." (Little Sisters of the Poor, Evansville.)

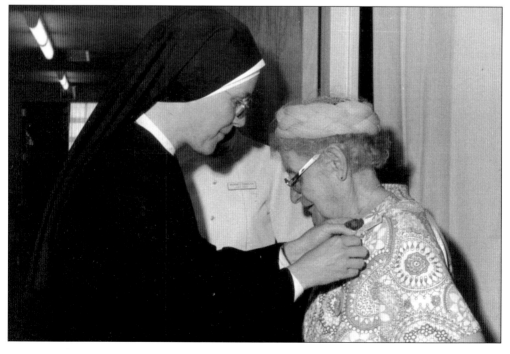

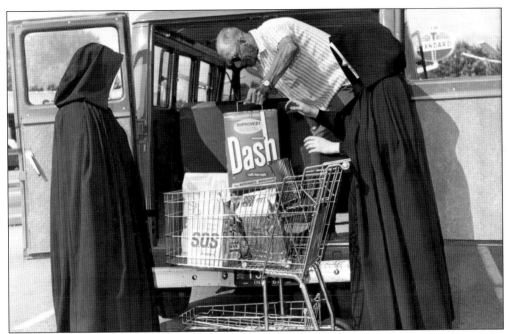

To fund their early ministries in Evansville the Little Sisters were known around the city for their begging van. The sisters would go door-to-door begging for donations to operate their home and care for their residents. In this picture from the 1960s, a volunteer worker assists the sisters to unload donations from a local store. (Little Sisters of the Poor, Evansville.)

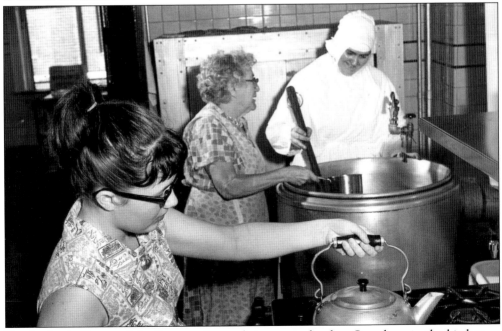

For the Little Sisters of the Poor service work is never a burden. Seen here in the kitchen at the St. John Home, a sister is assisting volunteers to prepare breakfast. While the sisters share responsibilities for household duties, their greatest gift remains spending precious time with residents in life's final hours. (Little Sisters of the Poor, Evansville.)

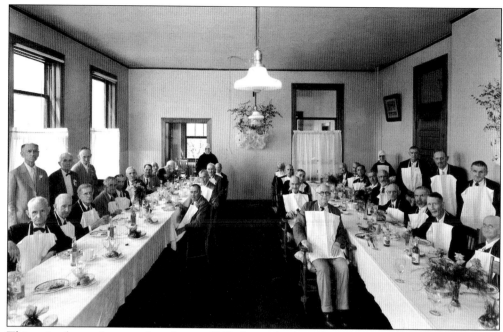

This pair of rare photographs taken in 1938 shows the formal dining room of the Little Sisters' home. Men (above) and women (below) were separated during meals, and fine dress was encouraged. Given that the sisters serve the poorest of poor and those without family and loved ones, as well as those with very involved medical needs, the sisters are very committed to human dignity. Even today with all the government regulations in place to monitor nursing homes, the sisters work hard to make their facilities comfortable, accommodating, and as much like a home as possible. (Little Sisters of the Poor, Evansville.)

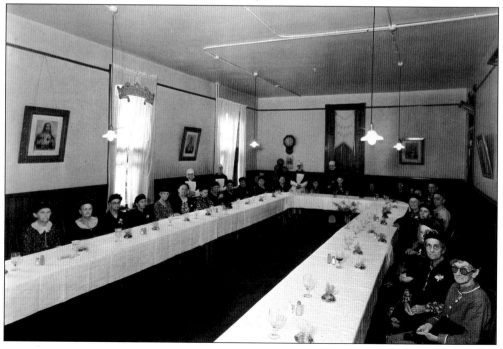

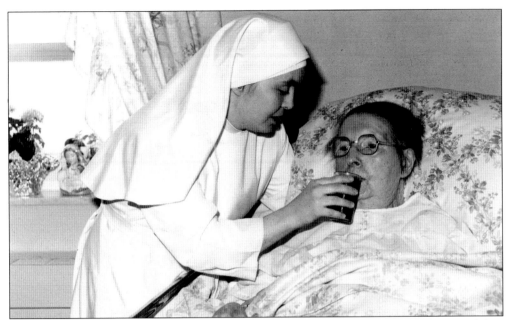

In the early 1870s, Father Bessones, vicar general of the Diocese of Vincennes, invited four sisters to two small rented houses on Vermont Street in downtown Indianapolis. These Little Sisters of the Poor invited six guests into their homes and like their counterparts around the world they began their mission to provide comfort to the suffering. (Archdiocese of Indianapolis Archives.)

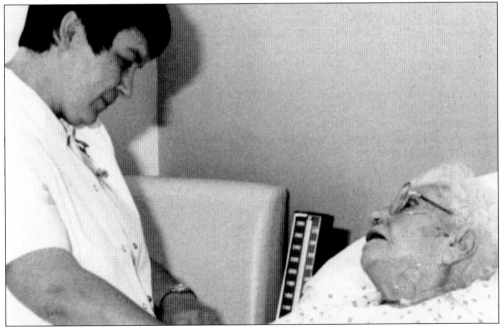

The Sisters of St. Joseph often comfort the ill and aging in their Tipton infirmary. Seen here at the St. Joseph Infirmary in 1985 is Sister Loretta Ann with patient Rose Klemme in her final moments of life. The sisters are adamant that residents never face their final moments of life alone. (Sisters of St. Joseph, Tipton.)

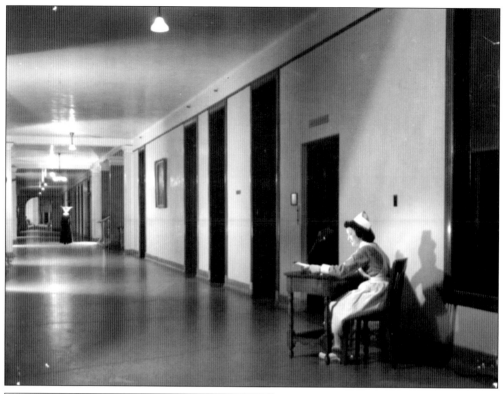

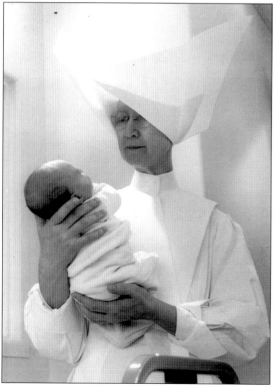

The future of healthcare services in Indiana is sure to include the works of the fathers, brothers, friars, and sisters of the Catholic religious communities. As a student nurse studies a chart, an unidentified Daughter of Charity keeps vigil in the halls of St. Vincent Hospital (above), much like all healthcare sisters will continue their masterful watch over the hospitals in Indiana. As if this helpless infant symbolizes the frailty of the human condition, and as a picture touches the heart and soul beyond the capability of words, this image of Sr. Mary Stella Simpson tells the sisters' story well (left). (Above, St. Vincent Hospital Archives, Indianapolis; left, Daughters of Charity Archives, Evansville.)

Three

More than Reading, Writing, and Arithmetic

In response to the pleas from the bishops and local parishes for educators, several orders sent missions to Indiana beginning in 1840. In western Indiana, St. Mother Theodore Guerin and the Sisters of Providence established an academy, and across the state at the eastern border Sr. Theresa Hackelmeier and the Sisters of St. Francis launched educational programs for the German-speaking children residing in and around Oldenburg. This pattern of religious orders meeting the area educational needs was expressed in the north by the Sisters of St. Joseph and the priests, brothers, and sisters of the Congregation of Holy Cross, and in the south by the Sisters of St. Benedict and the Conventual Franciscan Friars of Our Lady of Consolation. Education was a primary mission of many of the religious communities arriving in early Indiana.

If not directly involved with founding primary and secondary schools, the various orders were often invited to staff local parish schools. Fathers, brothers, sisters, and friars strongly tied to Indiana frequently found themselves leading educational missions outside the state, in the western states, South America, and the Caribbean. In all these locations, the provision of education became a constant in the growth of the orders and success of local communities, impacting not just Indiana but the United States and beyond.

While prior generations of Catholics remember receiving instruction primarily by teachers who were members of Catholic religious orders, it is now common that students receive instruction from lay teachers. In most instances, official affiliations with the orders still remain strong. As the number of Catholic religious men and women contracts, their footprints can still be seen in school names, faith-based curriculums, and ever-present religious art, statuary, and artifacts. Whether by divine design or secular realities, connection to religious communities continues, if not directly in the classrooms, then in school administration, boardrooms, and hallways; the students taught by members of the orders are frequently the ones delivering instruction to the students of the many Catholic primary and secondary schools in Indiana today.

This seldom seen painting of St. Mother Theodore Guerin, founder of the Sisters of Providence in the United States, depicts her love for children as she reads from her Bible. As the sisters established themselves as educators with Saint Mary's Academy in 1841 (now St. Mary of the Woods College), their reputation flourished. Calls for assistance to begin new education ministries steadily increased. Aside from schools in Indiana, the sisters can be found teaching as far away as China. (Sisters of Providence, St. Mary of the Woods.)

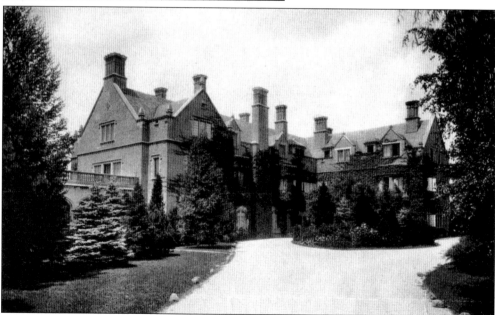

While the versatile Sisters of Providence could be found in several elementary schools in Indiana and around the country, they were just as visible within the secondary education community. Pictured here is an early image of the Fletcher House Manor Estate in Indianapolis that became the home of Ladywood Academy, a female boarding college preparatory school in Indianapolis. (Sisters of Providence, St. Mary of the Woods.)

The immaculate grounds and classrooms of Ladywood were elegant, as depicted in these early views of the springhouse (right) and music room (below). The springhouse offered a quiet respite from the daily stress of accelerated studies, while the music room allowed opportunities for individualistic expressions. The Sisters of Providence were always advocates of the therapeutic qualities of music and insisted that music education be integrated into student life. While the campus was entrenched in a world of natural beauty complete with facilities rich in amenities, Ladywood students were required to be disciplined in their studies as characteristically mandated by the sisters. (Sisters of Providence, St. Mary of the Woods.)

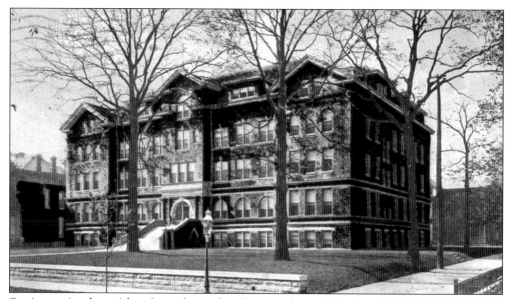

St. Agnes Academy (above) was located at Fourteenth and Meridian Streets in Indianapolis. The second building is shown here around 1950. This building still stands and is operated privately as St. Agnes Apartments. Ladywood Academy was also located in Indianapolis at Fifty-sixth Street and Emerson Avenue. Both all-girl schools flourished into the 1970s, when they merged, becoming Ladywood St. Agnes Academy. The Brothers of Holy Cross founded the all-male Cathedral High School in 1918, located immediately north of St. Agnes Academy in the building now housing the Indianapolis Catholic Center. In the 1970s, Cathedral merged with Ladywood St. Agnes and relocated to the original Ladywood Academy property. With that merger the school became the present coeducational Cathedral High School. Below is a picture of the 1943 St. Agnes Academy graduation ceremony held at SS. Peter and Paul Cathedral. (Sisters of Providence Provincial Archives.)

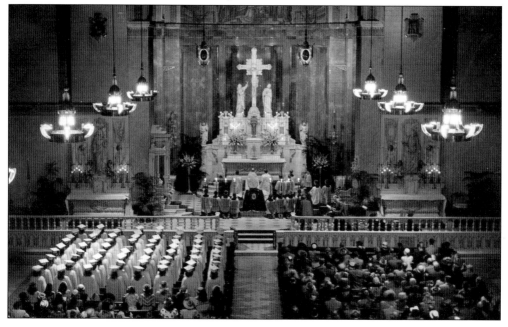

The Sisters of Providence are
known for their social activism on
behalf of individuals marginalized
by society. Here are two 1965
examples of the sisters work
in Albany, Georgia, during
the struggles of the civil rights
movement. Sisters would enter
segregated schools in impoverished
areas to provide instruction to
African American children.
These efforts were often met
with rejection from the larger
community, as well as outright
racial hostilities. The sisters
focused on group activities but
gave individualized attention
to those students requiring a
additional assistance. The sisters
continued this work until tensions
were minimized and civil rights
reaffirmed. (Sisters of Providence,
St. Mary of the Woods.)

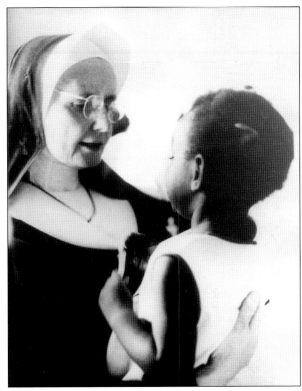

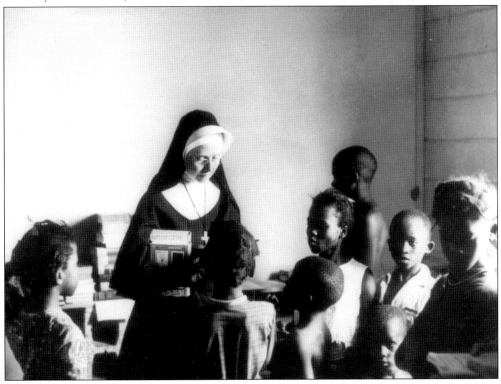

The Reception Committee of St. Patrick parish in South Bend met for the consecration of the church. A school was built in 1893 at a cost of $14,000 and featured three classrooms, a social hall, a meeting room, and a gymnasium. The original school was an all-male institution, and 150 boys attended classes originally conducted by the Sisters of the Holy Cross. (Priests of Holy Cross Indiana Province Archives.)

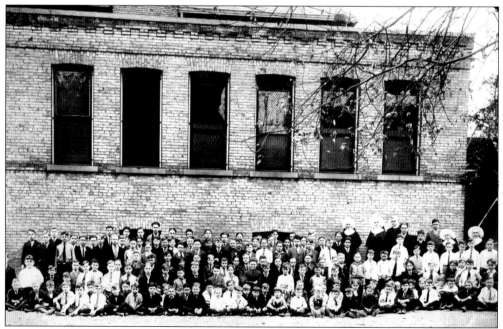

This 1924 picture shows all eight grades of students at St. Patrick School. While only males could enroll in classes at the original school, a girls' school was built on adjacent property to serve female children. During the life of the schools, the Holy Cross priests, brothers, and sisters all taught at the school in various capacities. (Priests of Holy Cross Indiana Province Archives.)

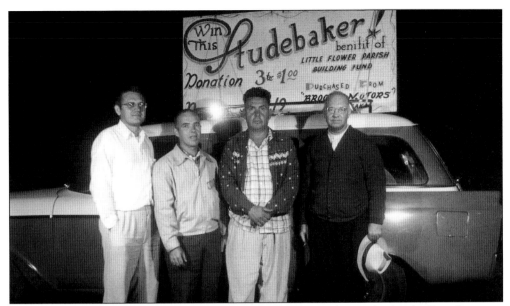

The Holy Cross priests staffed several South Bend area parishes and schools. Seen here is a typical 1950s building fund-raiser (above). The building committee and pastor Fr. Joseph Payne (far right) are standing in front of a Studebaker that was manufactured in South Bend. Once adequate funds were raised, construction would immediately follow. Pictured is the 1954 groundbreaking ceremony for Christ the King Church (below). Of the delegates holding the six shovels, representatives from the 1954 school building campaign include Clarence H. Loebach (second from right) and Clarence's wife (third from right). The swelling Catholic population in the South Bend area necessitated apt fund-raising and constant facility planning. (Priests of Holy Cross Indiana Province Archives.)

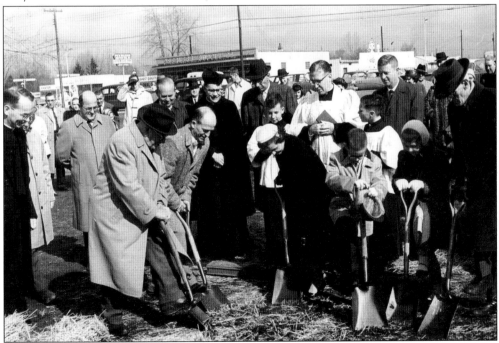

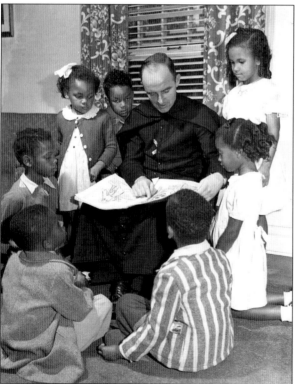

South Bend was home to a diverse population. In the 1930s, the Holy Cross priests began their first African American ministry at St. Joseph's Church (above). A large African American crowd encircles the church property demonstrating the need and popularity of the ministry. St. Joseph Church was built with wood instead of stone or brick, modest in design and ornamentation, suiting the working-class neighborhood. African American ministries were both popular and common well into the 1950s and 1960s. Fr. Vince Thilman reads a book to the children of St. Augustine parish in 1952 (left). The Holy Cross priests were dedicated to both formal and informal educational outreach in African American and other ethnic neighborhoods. (Priests of Holy Cross, Indiana Province Archives.)

The Holy Cross brothers taught at many secondary schools and colleges in Indiana. In 1962, Brother Donard taught physics and math and also had a photography club for interested students (right). Brother Donard had the necessary chemicals and equipment in a dark room so his students could take, process, and print their own photographs. Brother Marius enjoyed teaching high school biology in the 1950s; he was known to take his class outside to explore nature's "classroom" (below). The brothers worked at central Catholic High School in Fort Wayne, Reitz Memorial High School in Evansville, Cathedral High School in Indianapolis, Central Catholic and St Joseph's High Schools in South Bend, and a host of others around the country. (Brothers of Holy Cross Archives.)

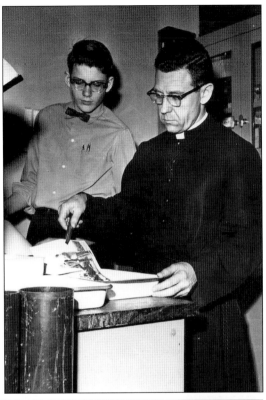

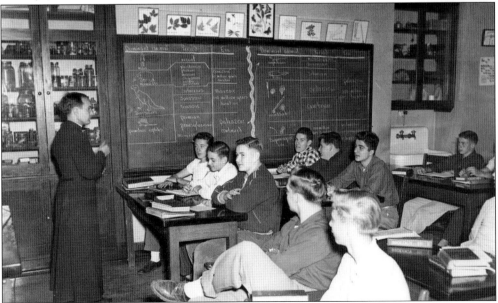

Indianapolis Cathedral High School continues to be a premier private college preparatory school in Indianapolis. Dedicated to Catholic values, the school is privately operated under the auspices of the Archdiocese of Indianapolis. The Holy Cross brothers operated the school until the 1970s, when it merged with Ladywood St. Agnes Academy, forming a coeducational school. Seen here in 1962 at Cathedral is popular teacher Brother James. (Brothers of Holy Cross Archives.)

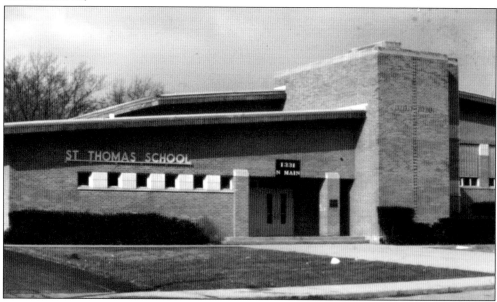

The Holy Cross sisters administered, taught, and provided religious education in several northern Indiana area elementary schools, answering numerous requests by the diocese to assist in parish schools. The sisters taught at St. Thomas the Apostle School in Elkhart from 1950 to 1990. Various religious communities became firmly intertwined with specific parishes due to constant visibility and longevity of ministry, generally residing at parish rectories and convents. (Sisters of the Holy Cross, Notre Dame.)

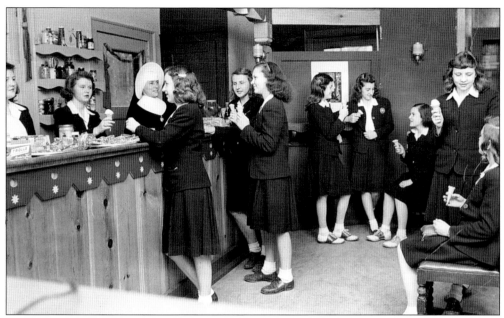

Located on the sprawling Saint Mary's College campus until 1945, Saint Mary's Academy was relocated to the Erskine Estate in South Bend. Sister Mary Amanda and students are seen enjoying ice-cream cones at the San-Bar, a very popular campus hangout in 1946 (above). Holy Cross sisters were often seen with students outside the classroom, modeling the integration of Christian living into secular life, including sports and other extracurricular activities. During the 1947–1948 academic year, several students are seen back in the classroom in this photograph of a Latin club with Sister Cecile Marie (below). School-related clubs and functions were an important part of student social life at Saint Mary's Academy. (Sisters of the Holy Cross, Notre Dame.)

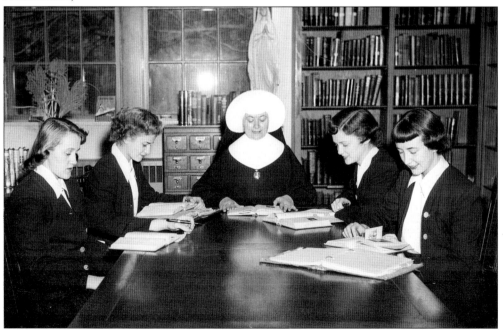

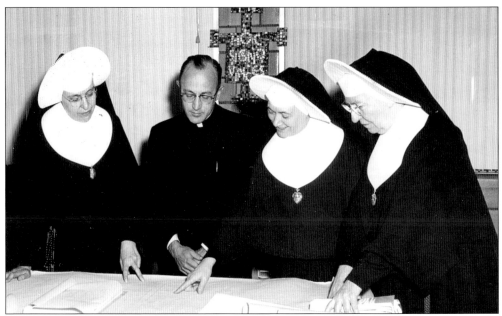

A new building was needed for Bishop Noll High School that had opened in 1933. The principal of Bishop Noll was Rev. A. J. Zimmerman. Seen above in 1961, Father Zimmerman and the Holy Cross sisters examine plans for the new building; from left to right are science teacher Sister Scholastica, Father Zimmerman, co-principal Sister Cecile Marie, and English and Latin teacher Sister Mary Victorine. The 1960s were quite exciting, and Sister Joseph Mary shared the news through the Holy Cross exhibit at the Catholic Students' Mission Crusade at Notre Dame (below). Sister Joseph Mary was a Bishop Noll alumna and had taught at Holy Cross College, Dacca, East Pakistan. Exiled archbishop of Peking Thom Cardinal Tien, SVD, and Rev. Clifford King, SVD, founder of the Crusade, are seen visiting at the display. (Sisters of the Holy Cross, Notre Dame.)

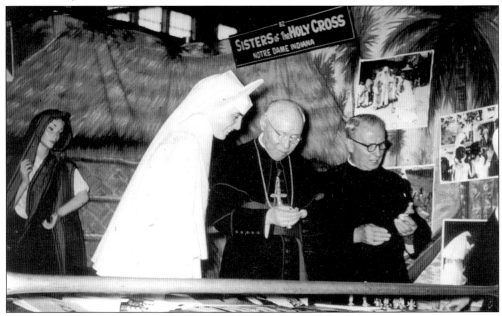

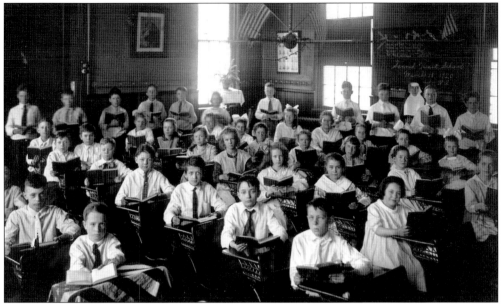

The Sisters of St. Francis of Oldenburg were visible in many elementary schools in the United States. In 1920, at St. Sacred Heart, Sr. Mary Jane Peine and her fourth-grade class take a moment to pose for this photograph (above). In this picture it is clear that boys were kept separated from the girls. Boys are dressed formally with ties. Three American flags are visible, stressing the importance of patriotism. Visiting Sr. Mary Janice Scheidler's class at Our Lady of Lourdes in Indianapolis in 1958 would be a different experience (below): boys and girls intermingle; classrooms are smaller; and more emphasis on direct teacher-student interaction is shown. (Sisters of St. Francis, Oldenburg.)

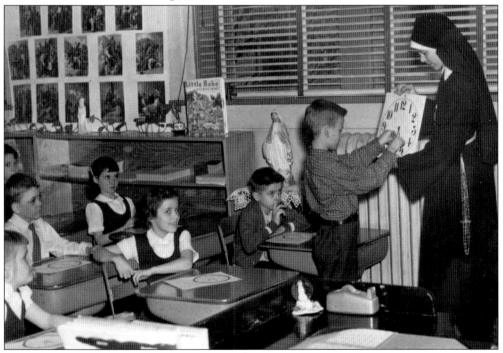

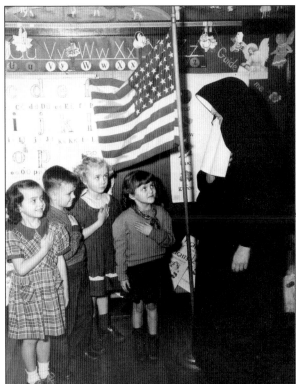

Although many aspects of the classroom instruction change with time, patriotism remains an important component of classroom teaching in Sr. Rosemary Meadows's 1951 first-grade class at Holy Trinity School in Indianapolis. Small class size, direct and informal interaction with the teacher, relaxed dress, and an emphasis on educational basics characterize several of the classrooms staffed by the Sisters of St. Francis of Oldenburg. (Sisters of St. Francis, Oldenburg.)

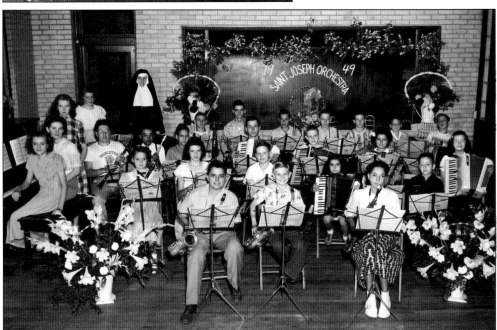

At St. Joseph School in Princeton, Sr. Francis Theresa Heitter poses with the school's orchestra. Music ministry is an important part of the Sisters of St. Francis school heritage and ministries. The sisters often arranged for school choirs, orchestras, and bands as well as individual recitals to be performed in public venues. (Sisters of St. Francis, Oldenburg.)

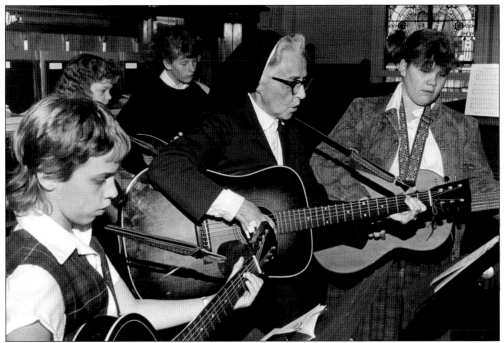

Sr. Bertha Wolfer gives guitar lessons to small groups of students at St. Aloysius School in Covington, Kentucky (above). Aside from music that could be played during guitar mass, Sister Bertha was known to teach her students a few contemporary tunes during her tenure at the school in the 1980s. Below, Sr. Francis Jean Sandschulte conducts the St. Catherine School Orchestra in this 2000 auditorium performance. Given the large number of students in the orchestra and the size of the crowd that attended the performance, music is certainly a popular ministry for the sisters. (Sisters of St. Francis, Oldenburg.)

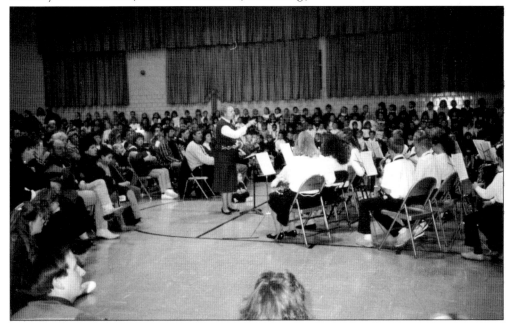

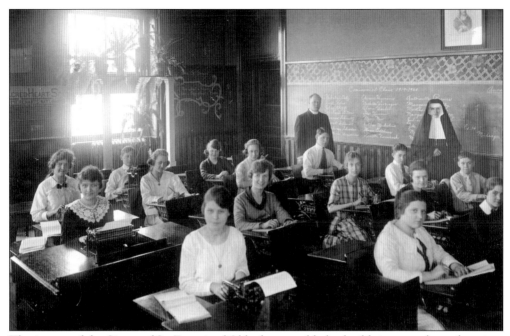

The impact of the Sisters of St. Francis of Oldenburg could also be felt in secondary education. In this 1919 photograph of the commercial education class at Sacred Heart, female students are being taught typewriting skills. Since most females at that time did not attend college, it was important to build marketable skills in the classroom. (Sisters of St. Francis, Oldenburg.)

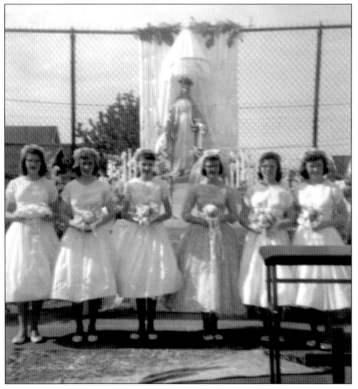

Catholic schools differ from their public counterparts in many ways. The Sisters of St. Francis of Oldenburg imparted a strong education to their students, along with a love of the ritual and mystery surrounding the celebrations of the church. In this picture taken in 1959 at Holy Trinity in Indianapolis, students are participating in a May crowning to honor the Blessed Virgin. (Sisters of St. Francis, Oldenburg.)

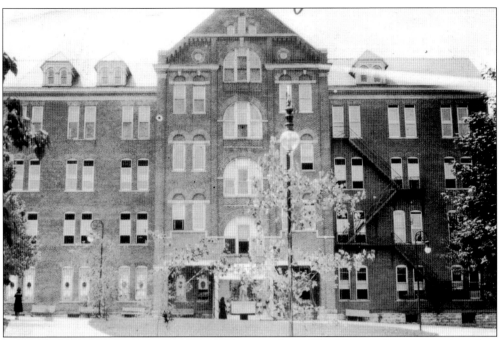

Immaculate Conception Academy originally opened in 1852. The academy was enlarged in 1875 and again in 1901, as seen above in this 1923 photograph of the north entrance. In 1968, a new academic building, music building, and gymnasium were added to the campus, and those buildings today form the main academy facility. The once all-female school is now a private, coeducational college preparatory school currently serving over 200 students under the direction of the Sisters of St. Francis. Immaculate Conception Academy is dedicated to development of the whole person. In an earlier time young ladies were far less likely to go to college or enter into business, so in addition to the basic academic subjects there was also a focus on social graces and fine arts popular in genteel society such as this 1919 class in china painting (below). (Sisters of St. Francis, Oldenburg.)

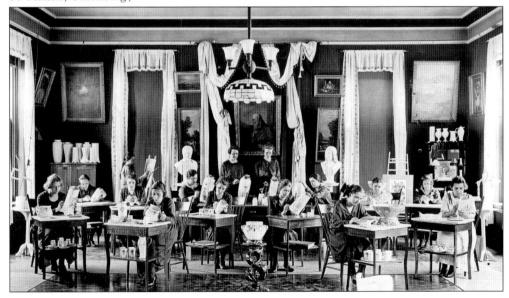

This 1920s postcard shows the students of the St. Meinrad sponsored and staffed all-male Jasper Academy. In 1933, the Benedictine monks of St. Meinrad merged Jasper Academy with the Augustinian administered Fox Valley Catholic High School, which was returned to the diocese of Rockford, Illinois, during the Great Depression. This series of events resulted in the formation of Marmion Academy in Aurora, Illinois. (St. Meinrad Archabbey Archives.)

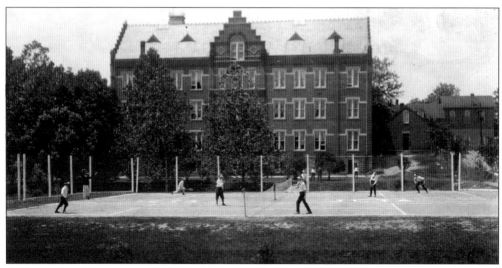

As Jasper Academy grew, so did its emphasis on whole person development and sports. Pictured is the academy's successful tennis team during a practice in the 1920s. The main academic building and residential building can be seen in the background. Notice that the gentlemen students are playing in long pants. (St. Meinrad Archabbey Archives.)

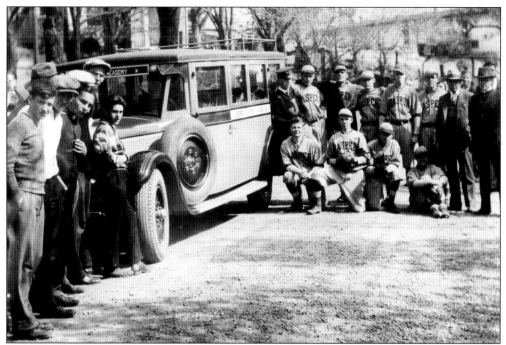

Aside from tennis, Jasper Academy students had opportunities to play organized sports including basketball, football, and baseball as well as to engage in individual exercise like walking the academy grounds and swimming. The baseball team can be seen in this 1930s picture with team support personnel, parents, and fans (above). One of the team's transportation vehicles is also seen with the school's name clearly visible. Jasper Academy students are also seen swimming in a photograph labeled "summer vacation 1926" (below). Note the modest housing surrounding this early public pool and the formality of dress not typically found around today's aquatic centers. (St. Meinrad Archabbey Archives.)

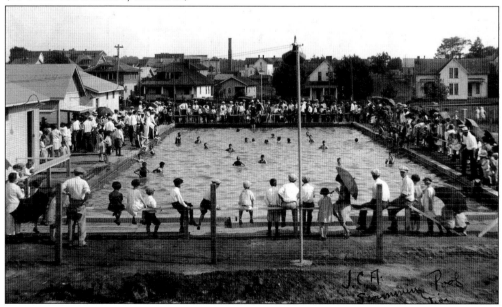

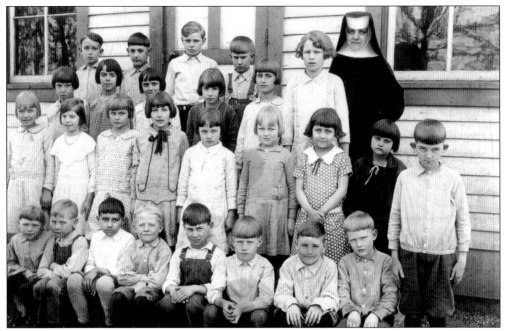

The Benedictine sisters from Monastery Immaculate Conception were also called to teach in many urban and rural primary and secondary schools. This photograph from 1930 shows Sr. Helen Wagner with her students at St. Henry School. Indiana's agricultural background is reflected in the dress of the boys. Not all the students look thrilled to be posing for a photograph. (Sisters of St. Benedict, Ferdinand.)

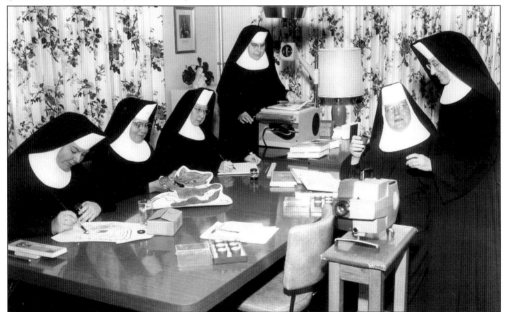

When classes end and students leave for the day, it is finally quiet enough to begin planning for the next day. Complete with scissors, paint, and glue, three Benedictine sisters are busy preparing for their classes, while three others are working with then modern technology—the dreaded overhead and filmstrip projectors. (Sisters of St. Benedict, Ferdinand.)

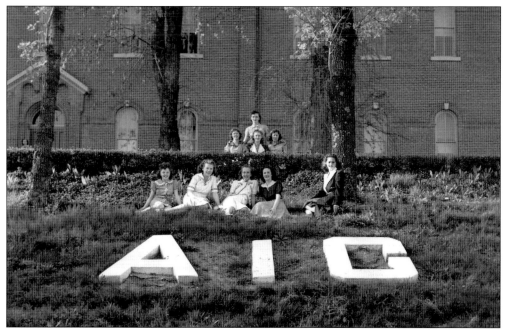

Academy Immaculate Conception opened in 1870 to educate girls in discovering and mastering fine and practical arts. This 1950s photograph shows academy students posing at the top of the hill embedded with the school letters. Facing a gradually declining enrollment in the late 1990s, the sisters reluctantly closed the academy in 2000. (Sisters of St. Benedict, Ferdinand.)

The Sisters of St. Francis of Perpetual Adoration came by invitation to Lafayette in 1875. Sister Mary Rose was one of the original sisters to settle the new Indiana ministry. She is seen in this historic photograph with her students at St. Boniface School in the late 1800s. The sisters eventually relocated their motherhouse to Mishawaka to continue their many ministries, including education and healthcare. (Sisters of St. Francis, Mishawaka.)

The Franciscan sisters' ministry at St. Boniface School continued into the next century. Sister Mary Consortia is seen with her kindergarten class in 1948 enjoying the sounds of a record and reading. The Sisters of St. Francis of Perpetual Adoration are most widely known throughout the state for their extensive healthcare services. The Sisters of St. Francis Health Services corporation includes a number of major hospitals, medical office complexes, clinical services, and similar related facilities. They are less known for their widespread educational activities that included staffing elementary schools at Our Lady of Grace in Highland, Sacred Heart School in Remington, and numerous others. The sisters also founded St. Francis College in Lafayette. The college, now known as St. Francis University, was relocated from Lafayette to Fort Wayne and continues to operate under the administration of the sisters. Like the other religious communities, the sisters never hesitated to enlarge their missions to accept a call to apply their resources to fill a social need. (Sisters of St. Francis, Mishawaka.)

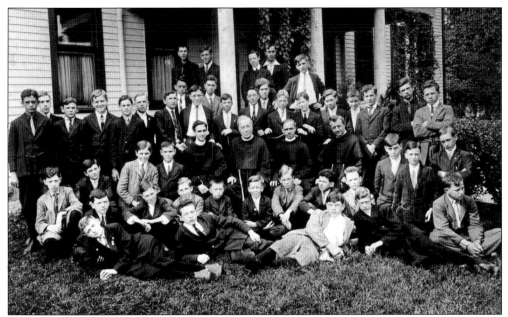

Prior to opening a retreat center in 1975, the Conventual Franciscan Friars of Mount St. Francis ran a high school seminary for young men on 400 acres of wooded land donated by actress Mary Anderson. Upon graduation, students were strongly encouraged to remain with the order and become a friar. This photograph from 1912 shows the entire student body with faculty found near the middle of the image. (Friars of St. Francis, Mount St. Francis.)

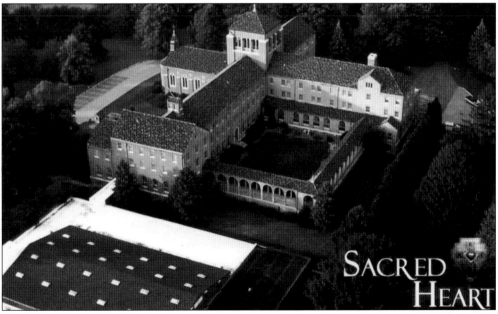

This is a recent postcard aerial view of the secluded Sacred Heart Apostolic School in rural Rolling Prairie. Owned and operated by the non-Indiana based Catholic society known as the Legionnaires of Christ, this secondary grades boarding school is housed in the buildings that formerly were the Congregation of Holy Cross Novitiate. (Authors' collection.)

The Benedictine sisters at Our Lady of Grace opened a boarding and day academy on the monastery grounds shortly after their arrival in 1955. The academy flourished during the 1960s and 1970s, when such schools were popular. Declining enrollment eventually led to the closure of the school, and the buildings now serve the community as the Benedict Inn Retreat and Conference Center. (Sisters of St. Benedict, Beech Grove.)

In simpler times children could be found on a warm day gathered at the foot of a Daughter of Charity for friendship and a story. Times have changed, but the memories and benefits of a Catholic education remain. It may have been warm in the dress and habit of a Daughter of Charity, but certainly not as warm as her heart. (Daughters of Charity Archives, Evansville.)

Four

COLLEGES AND
UNIVERSITIES

The Congregation of Jesus and Mary, commonly known as the Eudist Fathers, began the tradition of Catholic higher education in Vincennes with the founding of St. Gabriel's College in 1836. Only Territorial University, established as a private institution by Samuel Scott in 1910, the nucleus of the modern-day Vincennes University, preceded St. Gabriel's College. Although the Eudists' efforts were short-lived and their college was gone by the 1840s, other Catholic colleges and universities were taking root across Indiana. Ten Catholic colleges and universities continue to survive and prosper to this day in Indiana: St. Mary of the Woods (1841, Sisters of Providence); University of Notre Dame (1842, Priests of Holy Cross); Saint Mary's College (1844, Sisters of the Holy Cross); St. Joseph's College (1889, Missionaries of the Precious Blood); University of St. Francis (1890, Sisters of St. Francis of Perpetual Adoration); Ancilla College (1937, Poor Handmaids of Jesus Christ); Holy Cross College (1966, Brothers of Holy Cross); Calumet College (1974, Missionaries of the Precious Blood, preceded by St. Joseph's College Calumet Center and St. Joseph's Calumet College); St. Meinrad School of Theology (1999, Benedictine Fathers, preceded by St. Meinrad College and Seminary founded 1861); and Marian University (2009, Sisters of St. Francis, Oldenburg, preceded by St. Francis Normal School for Women, which merged with Immaculate Conception Junior College to become Marian College in 1937).

While not forgotten, several Catholic institutions of higher learning have closed: Jasper College (Benedictine Fathers), St. Benedict College (Sisters of St. Benedict), St. Joseph's Junior College (Sisters of St. Joseph), West Baden College (Society of Jesus), and a handful of others. Ever responsive to the educational needs of Indiana students, the future of the remaining Catholic colleges and universities remains bright as rich histories, well-earned reputations, state-of-the-art facilities, and noted faculties continue to attract eager students. With lay professors and administrators more frequently teaching and governing Indiana's Catholic educational institutions, the fathers' cassocks and the sisters' habits are becoming less visible in the hallways of academia, yet the spirit and values of the founding religious communities remain clearly evident.

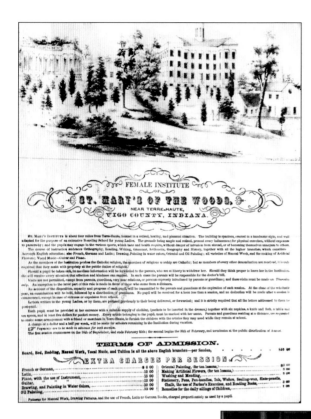

Founded just northwest of Terre Haute by St. Mother Theodore Guerin and the Sisters of Providence in 1841, St. Mary of the Woods was one of the first institutions of higher learning in the United States as well as the country's first liberal arts college for women. Seen to the left is the original promotional advertisement for the college. (Sisters of Providence, St. Mary of the Woods.)

The University of Notre Dame was established on November 26, 1842, by the Priests of Holy Cross as an all-male institution. While the first woman was not admitted until 1972, the Holy Cross sisters could be found in support roles around campus. Pictured here is Sister Mary Elfred, who worked in the Notre Dame laundry for 51 years. (Sisters of the Holy Cross, Notre Dame.)

A young student is dressed for winter weather on the Saint Mary's Academy campus in the early days. Founded by the Sisters of the Holy Cross in 1844, Saint Mary's Academy opened to serve precollegiate women, moving in 1855 to its present site in Notre Dame, where the facility grew to become Saint Mary's College. (Sisters of the Holy Cross, Notre Dame.)

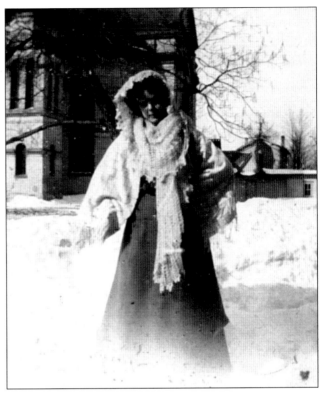

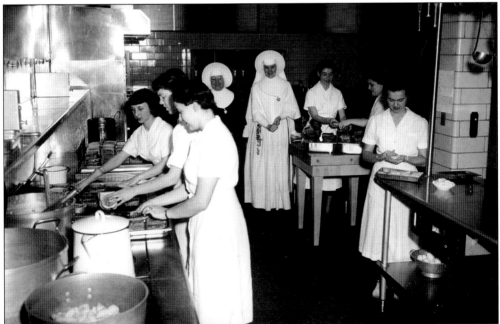

Seen here in the 1950s, home economics students from Saint Mary's College prepare a meal in the newly constructed Saint Mary's Convent. Home economics was formalized as an area of study at the college in 1903. Sister Mary Laurita and Sister Mary Agnes Anne are seen from left to right in the photograph. (Sisters of the Holy Cross, Notre Dame.)

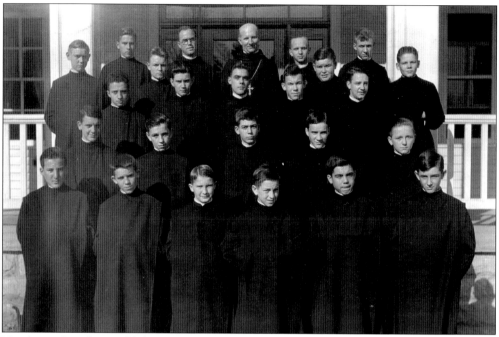

Not long after the establishment of St. Meinrad Archabbey, undergraduate coursework was offered. In 1861, undergraduate degrees were offered by the Benedictine monks in theology and philosophy resulting in the formation of St. Meinrad College. In 1998, the college closed, but the School of Theology continues. Seen here are the oblates in 1922. (St. Meinrad Archabbey Archives.)

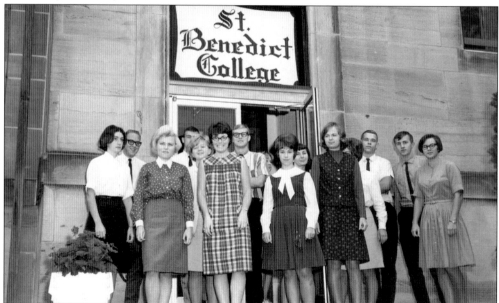

Southern Indiana had an abundance of postsecondary Catholic schools. The Benedictine sisters founded St. Benedict College in 1914 in Ferdinand and successfully operated the college until its reluctant closure in 1970. Pictured is an enthusiastic group of college students in the 1950s in front of the main entry door to the college. (Sisters of St. Benedict, Ferdinand.)

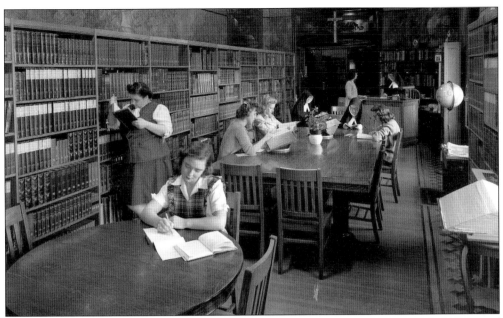

Founded in Lafayette in 1890 and relocated to the former 108-acre Fort Wayne estate of industrialist John H. Bass in 1944, the modern University of St. Francis is sponsored by the Sisters of St. Francis of Perpetual Adoration. Maintaining core Franciscan values, the university grew to add graduate programs in 1960 and currently serves nearly 2,000 students within 20 buildings; the original castlelike Bass Mansion remains a campus focal point. With grueling course work ahead, a reading room provides a pleasant study area for hardworking students (above). Sister Agnes (front) and Sister Mary Ann (rear) mingle with students in front of the science building (below). (Sisters of St. Francis, Mishawaka.)

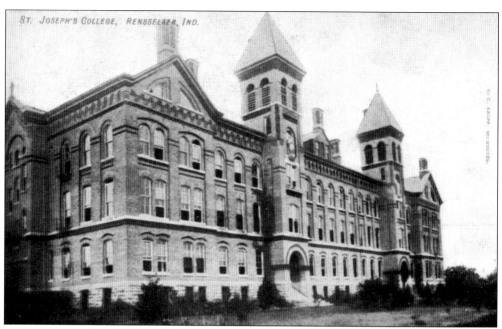

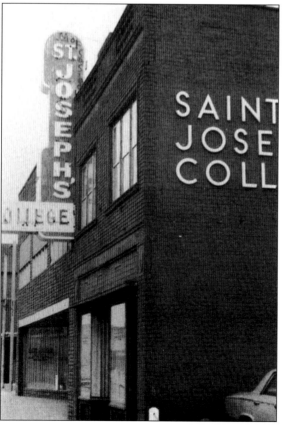

Although not an Indiana-based Catholic religious community, the Missionaries of the Precious Blood have a well-established educational apostolate in Rensselaer and the northern part of the state. St. Joseph's College, originally founded to provide secondary education to Native Americans, began serving general college students in 1891. Majestic Romanesque architecture and 340 acres of wooded landscape accentuate the liberal arts learning environment (above). Eventually St. Joseph's College established a storefront location to better serve nontraditional students who were unable to live at or travel to the rural residential campus (left). These centers eventually led to further planning and the establishment of the urban Calumet College of St. Joseph. (Above, authors' collection; left, Calumet College of St. Joseph.)

Originally as an extension of St. Joseph College at Rensselaer, Calumet College of St. Joseph was founded in 1951 from a storefront outreach location known as St. Joseph's College Calumet Center (above). Calumet College currently offers associate, bachelor, and master's degrees in a variety of academic and technical programs to nearly 1,500 diverse students. As a commuter student facility, Calumet College is housed in a single campus building in an urban setting (below) with additional locations in Chicago and Merrillville. As recently as 2001, athletic programs were added to the main campus amenities to further foster a sense of family and community. (Calumet College of St. Joseph.)

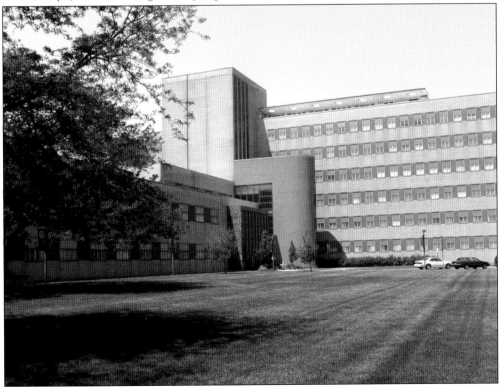

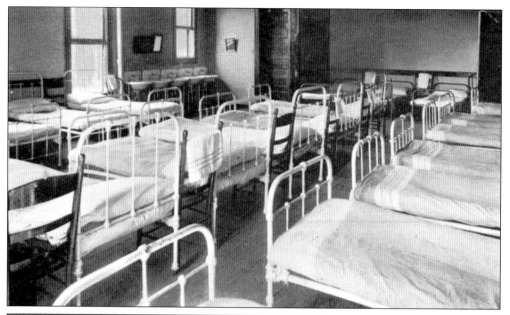

While currently Mount St. Francis is primarily a retreat center, an arts center, and residential complex for the Conventual Franciscan Friars, it once was a renowned seminary for young men contemplating the religious life. The friars operated a high school seminary until the mid-1970s but also hosted and taught college seminarians. This 1915 photograph shows the simplicity of the Franciscan life through an image of the main dormitory facilities for students (above). Also shown is current Mount St. Francis archivist Brother Larry in his former role as teacher (left). The brothers not only taught at Mount St. Francis, but often they were referred to area primary, secondary, and postsecondary schools to provide instruction. (Friars of St. Francis, Mount St. Francis.)

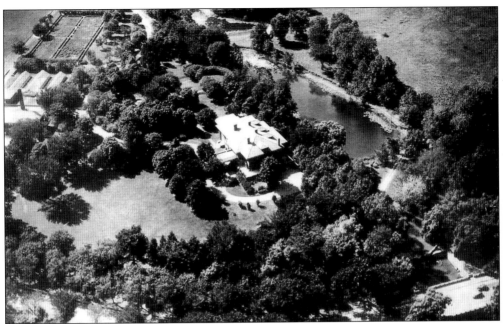

Settling in 1851, the Sisters of St. Francis of Oldenburg were called to develop a teacher training program for their own sisters in order to meet state-mandated educational standards. Eventually transforming into the four-year accredited St. Francis Normal, then merging with Immaculate Conception Junior College, the sisters bought the former James Allison Riverdale estate in 1936 with plans to relocate their teacher training programs to the larger urban area of Indianapolis. In 1937, Marian College was born as an all-female liberal arts college for teacher training. The sisters were quite proud of their initial enrollment of 24 students. The modest campus can be seen in this 1937 overview image (above). Seen below, from left to right, are original Marian instructor Sr. Gertrude Marie Zieroff with students Rita Sheridan, Ellen Eckrich, and Maria Porrás. (Marian College Archives.)

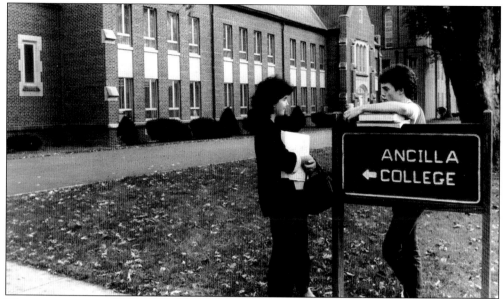

The congregation of the Poor Handmaids of Jesus Christ has sponsored Ancilla College since its inception in 1937 as an extension of DePaul University of Chicago under a granted charter. Originally the college functioned to educate potential new members of the Poor Handmaids, but with expanded facilities in 1966, Ancilla College enhanced its liberal arts offerings to prospective students. In 1967, the college awarded its first associate of arts degree. (Poor Handmaids of Jesus Christ.)

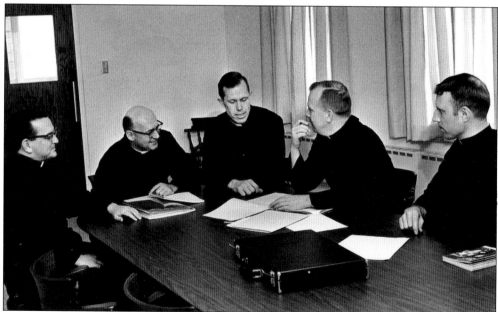

The brothers of the Congregation of Holy Cross began Holy Cross Junior College in 1966 to educate fellow brothers. In 1967, general male students were recruited, followed by a transition to coeducational opportunities in 1968. In 1990, the college officially changed its name to Holy Cross College. In 2003, the college began offering baccalaureate degrees in liberal studies, education, theology, and the arts. (Brothers of Holy Cross, Notre Dame.).

Five

AND THE
WORK CONTINUES

The ministries of Catholic religious communities expand beyond the schoolhouses and hospitals to touch Catholics and non-Catholics alike. Defying categorization, these works are as diverse as the communities' founders, saint namesakes, inspired missions, and individual members.

Picture the following: a homeless and hungry woman is fed through the outreach of the Albertine sisters in east Chicago; a depressed man questions the meaning of life and finally finds peace during a retreat conducted by the Franciscan Friars of the Immaculate; an orphan finds family through the programs of the Poor Handmaids of Jesus Christ; the St. Meinrad Fire Department saves a family home engulfed in flames; an ill child smiles at the antics of Sister Martha's clown ministry during an event sponsored by the Our Lady of Victory Missionary Sisters; a broken family comes together and delights at the splendor of the Salvatorian fathers' animated nativity scene; a Little Sister of the Poor comforts a husband who lost his wife of 50 years to cancer; a Benedictine sister from Monastery Immaculate Conception provides veterinarian services for an elderly gentleman's seeing-eye dog. These simple defining scenarios exemplify the compassion and sincerity of the men and women of the cloth who share everyday life not just in the churches but also in businesses, social services, daycare centers, and almost all secular settings.

Transcending service to individuals in crisis and need, members of religious communities are dedicated advocates on behalf of pro-life and human rights efforts, the abolishment of capital punishment, the environment, and the whole spectrum of social issues. Fathers, brothers, friars, and sisters can be found on the steps of city halls, among the crowds at political rallies, and counseling in jails and prisons. The members of Indiana's Catholic religious communities represent interests and beliefs when sickness, incarceration, or political agendas prevent voices from being heard. There are others who live in contemplative communities, praying for God's blessing upon the others in their missions and ultimately for their happiness and welfare. In so many ways, whether or not one is aware of their presence and actions, Indiana's Catholic religious communities touch everyone.

This 1880 hilltop view of the St. Meinrad Archabbey farm shows the typical harsh beauty of an Indiana winter (above). The operation was large enough to provide food for several hundred people through all the seasons. The archabbey was designed to be self-supporting when at full capacity. In contrast to the solitude of winter, the summer brought hired help from the surrounding towns (below) to assist the monks in the farm operations. The farm brought both an abundance of food to the archabbey and employment to the community. Aside from manpower, horses, mules, and modern steam engines were used to facilitate the work. The farm operation also included dairy, meat, and poultry production. (St. Meinrad Archabbey Archives.)

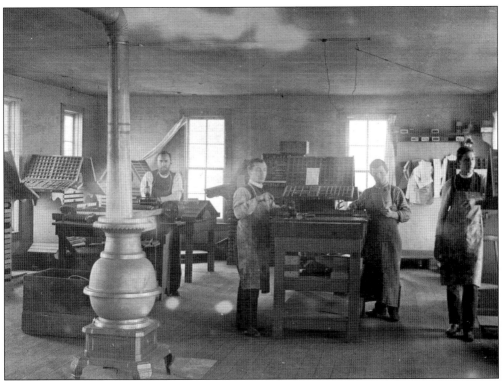

Abbey Press has operated for over a century on the grounds of St. Meinrad Archabbey. In this scene from the late 1800s, the print shop is a busy and crowded place (above). The monks were the primary workers at the press, and all typesetting was done by hand. The operation printed religious materials for the order as well as contracted work that generated needed revenue for the mission. By 1920, Abbey Press had grown large enough to add an annex and a delivery truck, both of which are visible in the image below. The truck has an abbey *A* on the driver's door as well as the company logo and *St. Meinrad* painted on the side. (St. Meinrad Archabbey Archives.)

Like Abbey Press in the south, Ave Maria Press flourished in the north. Located on the Notre Dame campus and operated by the Holy Cross priests, Father Reddington and Andy Pecze are seen finishing a job in the print shop (left). Ave Maria Press was so successful that an addition had to be added shortly after the original operation began. The press was one of the largest employers on the Notre Dame campus and had a huge parking lot to support the commuters (below). Ave Maria Press survives to this day to support the operational needs of Notre Dame University in addition to being a publisher of independent religious works. (Priests of Holy Cross, Indiana Province Archives.)

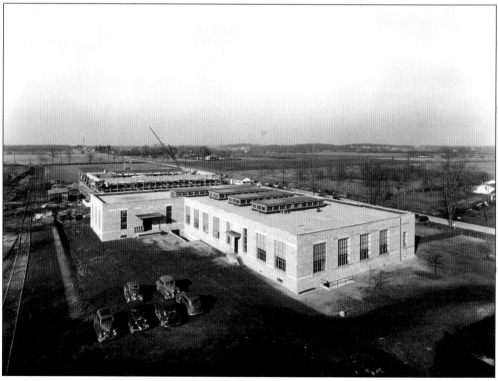

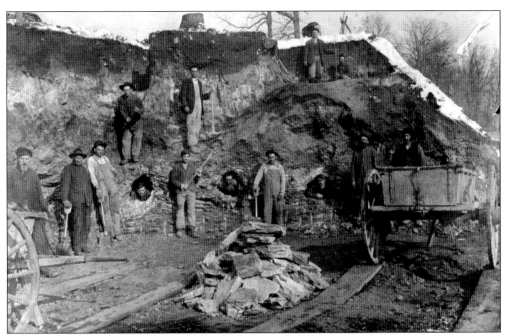

Just down the road northeast of St. Meinrad and the home of the Benedictine monks rested one of the largest commercial sandstone quarries of the time. Nestled below the bluff that held the archabbey's vineyards and Monte Cassino shrine, the sandstone quarry produced stone for the archabbey's ambitious building projects. The surplus sandstone was sold to support the monks' mission. This 1920s photograph shows the miners posing for the camera during a break (above). In a 1915 image the miners are seen on the landing above the quarry (below). It was difficult work to move the stone, and horse-powered wagons and creative devices made the job easier. (St. Meinrad Archabbey Archives.)

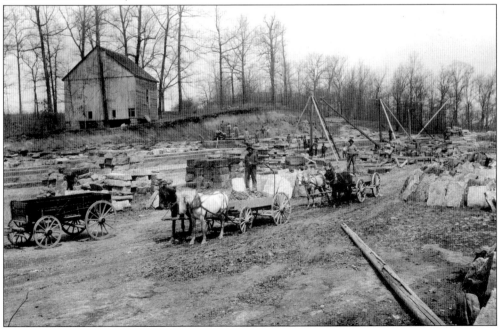

General religious mission houses were a common sight in urban areas (above). The houses offered respite from street life providing food, shelter, religious services, and hope to the hopeless. Fr. John Joseph Sigstein founded the Chicago Catholic Mission and later the Our Lady of Victory Noll Missionary Sisters, named for Our Lady of Victory and Bishop John Francis Noll, a staunch supporter and honorary cofounder of the sisters. Father Sigstein's friend and Chicago coworker Mr. Frey is considered the first associate of the sisters and worked with them from the beginning. His image is labeled in this 1905 photograph of mission volunteers (above). In 1961, Father Sigstein is seen with caregiver Sr. Florence Luechtefeld shortly before his passing (left). He envisioned the Holy Family building that was erected in 1960 at Victory Noll as a place of care for aged and ill sisters. (Our Lady of Victory Missionary Sisters Archives.)

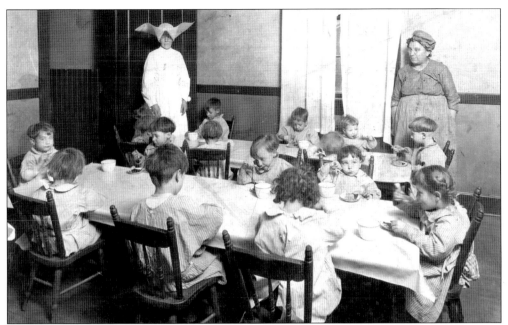

The Daughters of Charity have had several ministries since their 1872 arrival in Indiana. Aside from teaching and healthcare, the Daughters of Charity were active in providing daycare. This 1918 picture shows the children of St. Vincent Day Nursery sharing a meal together under the constant supervision of a sister (above). What nursery school would be complete without a nurse? It is playtime on a cold winter day in 1920 as the children await their parents' arrival at St. Vincent Day Nursery (below). A sister is seated and checking her log to discuss any matters of importance with the arriving parents. The blackboard states, "Suffer Little Children to Come Unto Me." Childcare was a common mission for several of the Catholic communities. (Daughters of Charity Archives, Evansville.)

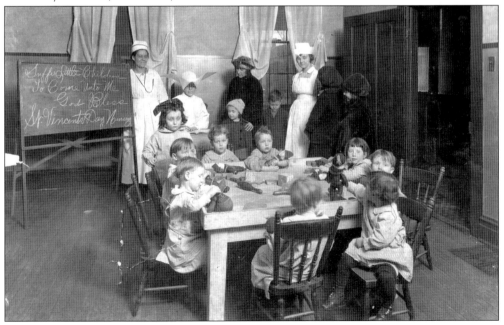

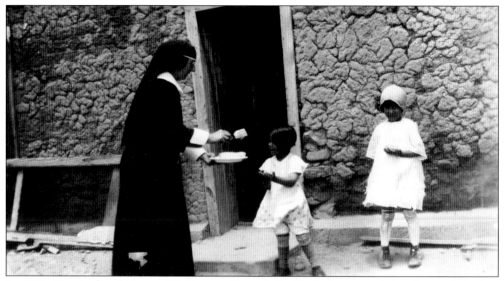

In 1923, Our Lady of Victory Missionary Sister Julia Doyle is seen ministering to fatherless children on a mission trip. Orphanages were common ministries during the world's recovery from World War I and later from the Great Depression. In the 1920s, the Poor Handmaids' Angel Guardian Home was also a provider of shelter and food for hundreds of children on any given day. (Our Lady of Victory Missionary Sisters Archives.)

Since the Catholic religious communities usually had the largest buildings in mostly rural areas, the orders often found themselves as the provider of community fire protection. Seen here in the early 1930s is an early fire cart, a predecessor to the modern firefighting equipment later acquired by the St. Meinrad Archabbey Fire Department. The department served the archabbey and the surrounding communities. (St. Meinrad Archabbey Archives.)

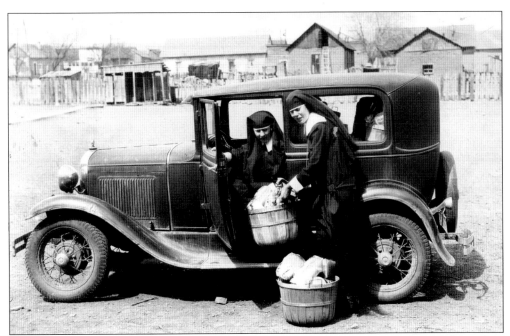

Early Our Lady of Victory Missionary Sisters Mary Genrose Sullivan (left) and Hannah Barthen (right) are seen in 1925 delivering food to the poor near Las Vegas, New Mexico (above). The sisters traveled by car to places in need of assistance and were known for their mode of transport, a novelty in the 1920s. Feeding the hungry was also a personal mission for Brother Jim of the Conventual Franciscan Friars. Brother Jim opened a very successful soup kitchen in Louisville, Kentucky. He is seen in this 1970s picture with community dignitaries who are making a donation to his efforts (below). (Above, Our Lady of Victory Missionary Sisters Archives; below, Friars of St. Francis, Mount St. Francis.)

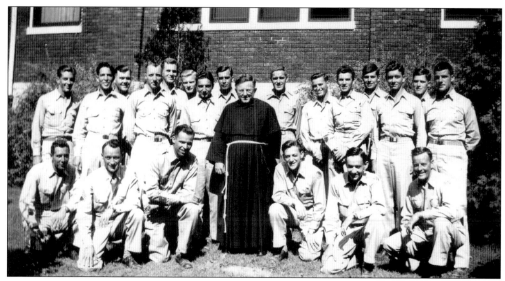

Retreats have always been a way to attract the attention of community members by offering a time and place to escape the daily stress of life and rediscover serenity. Today many Catholic communities have modern and popular retreat center ministries. Pictured in 1943 is a retreat group of World War II servicemen with the retreat facilitator. (Friars of St. Francis, Mount St. Francis.)

Several of the largest Catholic communities had dairy barns with milk production facilities. This is the dairy barn at Monastery Immaculate Conception. The monastery can be seen on the hill directly behind the barn. The dairies are no longer operating, but at Mount St. Francis, the dairy barn still remains and has been converted to artist studios. (Sisters of St. Benedict, Ferdinand.)

Our Lady of Victory Noll Missionary Sisters Mary Elizabeth Wengritzky and Magdalene Lenges are busy beekeeping in this 1955 photograph. The honey was used for food as well as medicinal purposes. Fathers, brothers, sisters, and friars have all done a variety of interesting and unusual work throughout the course of their ministries, including dog training, pizza making, and calling bingo. (Our Lady of Victory Missionary Sisters Archives.)

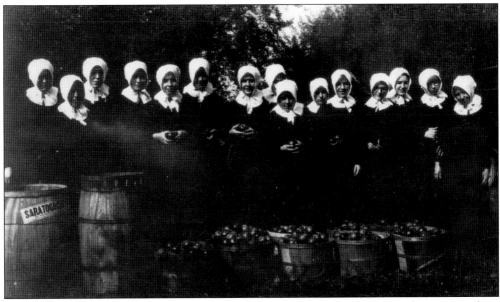

The Sisters of St. Francis of Perpetual Adoration had a nice apple orchard in Lafayette. Seen here are community members after picking several bushels in October 1928 for use in the community and to share in town. St. Francis was committed to nature and the bounty of the land. The Sisters of St. Francis at Oldenburg continue the tradition of farming and renewable food sources at the contemporary Michaela Farm. (Sisters of St. Francis, Mishawaka.)

Indiana's Catholic religious communities continue to be active voices in the fight for social justice. While the Sisters of Providence can be found rallying against the death penalty or advocating on behalf of AIDS patients, the Sisters of Benedict can be seen promoting the right to life or visiting prisoners. Social justice is included in the mission and values of the orders. This 1958 photograph shows two sisters from Our Lady of Grace Monastery after meeting prisoners inside the gates of the Indiana Women's Prison (left). In April 1960, Franciscan sister Mirella introduces Sen. John F. Kennedy to patients at St. Elizabeth Hospital in Lafayette (below). (Left, Beech Grove Public Library; below, Sisters of St. Francis, Mishawaka.)

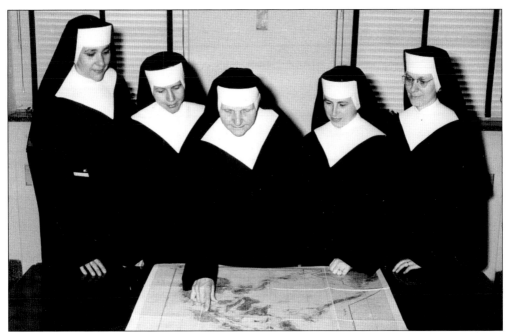

These Sisters of St. Francis in Mishawaka are planning for a mission in the Philippines in 1962. From left to right, Sister Annette, Sister Mark, Mother Philotera, Sister Mary Paul, and Sister Denise look at a map of their destination thousands of miles from their Indiana home. Many Indiana orders have missions outside the state and in other countries. (Sisters of St. Francis, Mishawaka.)

Brother Gonzaga Seton of the Holy Cross Brothers founded and operates a successful thrift store in northern Indiana seen in this 1990 photograph. Several religious communities are involved in resale shops or have members who volunteer to distribute donated goods. Many communities also have gift shops that sell religious books and articles with revenue being used to fund the work of the communities and social programs. (Brothers of Holy Cross, Notre Dame.)

Our Lady of Victory Missionary Sister Martha Wordeman enjoys making people smile through her clown ministry. Several communities of sisters in Indiana have a sister or two who enjoys working with children in the role of clown. Sisters visit hospitals, children's homes, events, and other community outreach programs where positive interaction and Christian message can make the greatest impact. (Our Lady of Victory Missionary Sisters Archives.)

The Benedictine sisters in Beech Grove have a community treasure with their facilities, many of which are remaining from the former academy. Aside from a full gymnasium, the sisters maintain a retreat center and inn, well-kept grounds, a labyrinth, and an indoor swimming pool. The facilities are all available for community use. The local Roncalli High School swim team practices at the pool. (Sisters of St. Benedict, Beech Grove.)

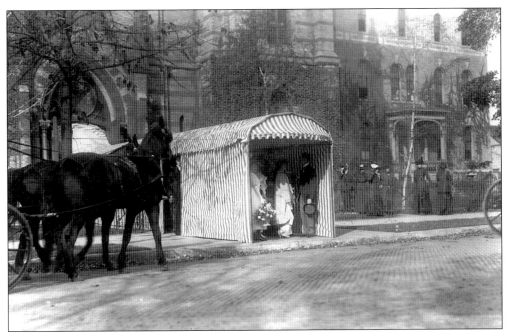

It must be noted that the primary purpose of Indiana's Catholic religious communities is to demonstrate God's love through the Catholic faith. The Priests of Holy Cross officiated at this 1913 wedding at St. Patrick Church. The sacraments are a visible reminder and promise of God's love for man. (Priests of Holy Cross, Indiana Province Archives.)

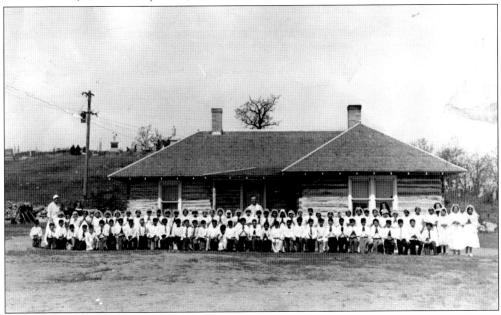

The sacrament of the Eucharist through communion is a precious moment for Catholics. The Benedictine sisters of Monastery Immaculate Conception provided instruction leading the children of this mission to the altar to receive their First Holy Communion. Countless Catholics have been taught the mysteries of the Eucharist by the sisters. (Sisters of St. Benedict, Ferdinand.)

The Sisters of St. Clare in Evansville support Indiana's Catholic Communities first with prayers. The Poor Clares have also provided several tangible services to the many Catholic parishes in the state. Pictured in the 1950s, the Poor Clares are seen making vestments and altar cloths, an invaluable service to the Catholic community (above). Seen in 1965, Sister Mary Celine is pictured using the convent's first eight-host cutter (below). Preparing the host for use was a ministry of the Poor Clares for many years, but due to the dwindling number of sisters, aging, health issues, and economics, the sisters discontinued this ministry. (Poor Clares, Evansville.)

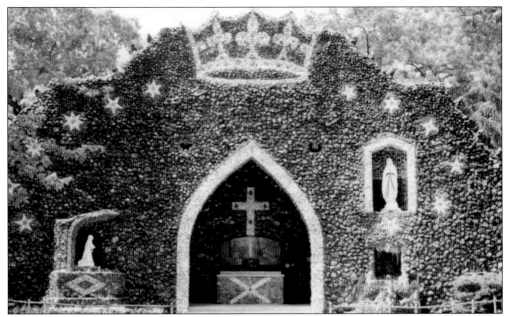

The Carmelite Sanctuary of the Virgin Mary in Munster is located in the midst of urbanization. The wooded grounds include several shrines and the pictured grotto. The Carmelite Fathers maintain the facility. The nearby Salvatorian Fathers are caretakers to the Shrine to Our Lady of Czestochowa. Each of the communities welcomes visitors and has spacious grounds for prayer and reflection. (Authors' collection.)

The most treasured Catholic tradition is the mass. The Franciscan friars at Mount St. Francis conduct a special midnight Christmas mass in the dairy barn. This special occasion was publicized in 1982 to area residents in the hope that the message of Christmas would remain readily accessible. Mount St. Francis also had special lit Christmas displays during the holidays. (Friars of St. Francis, Mount St. Francis.)

Fathers, brothers, sisters, and friars often say that the most important work that they do is with children. Our Lady of Victory Missionary Sister Martha Sijota comforts a little boy who has hurt himself playing basketball. While this picture was taken years ago, the image spans time. It is comforting to know that Indiana's religious members are still out there and waiting to help bandage wounds. (Our Lady of Victory Missionary Sisters Archives.)

Sacristan Poor Clare Sister Mary Nativity spends quiet time in reflection as she prepares the host for mass. So many times the work of the religious communities is not seen. But somehow the world has become healthier, more educated, and more peaceful through their efforts. Members of Indiana's religious communities do not have jobs and work to do, they have a way of life. (Poor Clares, Evansville.)

Six

RECREATION REFRESHES THE SOUL

Each Benedictine monastery has somewhere a sign that reminds all who see it that the rule of St. Benedict contains the phrase "Ora et Labora," literally translated to "pray and work." Since these are the activities that are generally seen in the public venue, many laypeople think that is all the religious actually do in life.

While it is certainly true that prayer several times each day is a part of daily life in a convent or monastery and emphasis is placed on the missions to be achieved, recreation is a natural part of the human condition. Recreational activities among the religious may take on a different nature than for the general public, but that does not make them any less refreshing.

Music plays a major part in the traditional life of a religious community, and choirs spend long hours working on liturgical pieces. Occasionally the music takes on a recreational form as a group of sisters records a CD or a monastic choir is able to take a road trip to perform in a different church or even a public concert. The music may remain the same, but the nature of the performance is a break from the normal routine.

Having taken a vow of poverty does not preclude one from enjoying an ice-cream treat now and then, and a serious card game will relieve the mind of daily concerns for a while. Wearing a religious habit does not limit reading to religious subjects or make a good mystery novel less interesting. Physical exercise promotes good health, so why should it not be a friendly tennis match or a little softball?

Many have likely heard someone comment that they would not want to join a religious community because the life is too strict or boring. The following few pages will hopefully put that rumor to rest.

In several religious communities, making liturgical vestments and altar cloth items was a regular occupation for sisters who were skilled seamstresses. Just as many people do, the sisters often took their work skills into a recreational mode, in their case to engage in crafting dolls. As seen in these photographs, the vestment departments at Monastery Immaculate Conception (left) and at the Poor Clares in Evansville (below) were the source of dolls dressed in their own particular habit. For some of the sisters who were good with needle and thread, the hobby extended to creation of dolls in the habits of many different orders, doll clothes donated to children's homes, and even entries in county fairs (note the prize ribbon on the dolls in the picture at left). (Left, Sisters of St. Benedict, Ferdinand; below, Poor Clares, Evansville.)

At St. Meinrad Archabbey, the use of traditional and ancient religious music is a regular part of the liturgical services, especially at major feasts and holy days. The chancel choir is seen in 1958 with director Fr. Lucien Duesing on the steps of the archabbey church (above). Coauthor John Murphy is in the first row, second from the right. Choir membership was a coveted extracurricular activity for students, much as athletics in other schools, combining the work of daily practice with the joy of performance. The choir frequently traveled to other venues for concert performances that always included an appropriate large dinner and celebratory party. The photograph below shows the choir at a concert performance under the famous dome of the West Baden Springs Hotel. Other concert venues included cathedrals of area dioceses and the Murat Theatre in Indianapolis. (St. Meinrad Archabbey Archives.)

The Sisters of St. Joseph at Tipton have a golf outing fund-raiser, so a few sisters (front, from left to right, Sisters Rosaline and Rosemary; back, from left to right, Sisters Christina and Dolorosa) decided to take a test drive in one of the golf carts. The smiles tell that the sisters were enjoying the day on the links. (Sisters of St. Joseph, Tipton.)

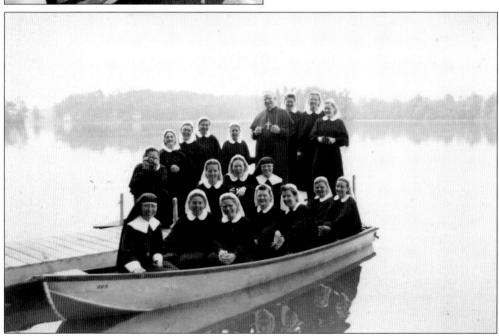

Bishop John Noll of Fort Wayne had an island property at Sylvan Lake that often hosted groups of religious of the diocese. Here a group of Our Lady of Victory Missionary Sisters is enjoying an afternoon on the water with the bishop, a welcome summer day away from work at the Huntington motherhouse. (Our Lady of Victory Missionary Sisters Archives.)

The Sisters of St. Benedict at Ferdinand did not have a large lake or boat for a summer retreat, but a shady spot on the monastery grounds made a perfect setting for a bit of ice cream and a card game. The sisters are seen during the 1966 Familien Fest, an annual day of relaxation that recalls the community's German heritage. The trick is eating the ice cream without drips on the starched white linen of the habit. (Sisters of St. Benedict, Ferdinand.)

This group of Sisters of St. Francis was likely recalling their youth as they roasted a few marshmallows on the open fire. The flames rising from a few of the roasting sticks suggest that the sisters' campfire skills may be a little rusty. Outings such as this give the dedicated sisters a break from their daily work. (Sisters of St. Francis, Mishawaka.)

The friars and their students at Mount St. Francis had the advantage of a small lake on the grounds, and a warm summer day in the 1940s found it being a perfect refuge from the daily work of teaching and studies. The lake is located well within the grounds of the monastery, thus providing a private recreation area. (Friars of St. Francis, Mount St. Francis.)

The Sisters of the Holy Cross operated many of the services at the University of Notre Dame in the early years. This break from work takes on a joyful sound as a "squeeze box" sets the tempo for an impromptu square dance. One can only wonder whether the sister looking through the window is enjoying the dance or waiting for her sisters to return to work. (Sisters of the Holy Cross, Notre Dame.)

For many years at St. Meinrad Archabbey, the major seminary students were allowed to enjoy a smoke, but only if it was a cigar or pipe. At the time, cigarettes were considered rather worldly, but this group of seminarians seems to enjoy looking appropriately scholarly with their pipes while taking a break from classes. (St. Meinrad Archabbey Archives.)

One advantage of having an academy on the grounds was the recreational facilities built for the students. Seen here in the 1940s, a group of the Sisters of St. Benedict enjoys the softball diamond behind Academy Immaculate Conception. Given the length of their habits, sliding into bases was probably not a part of this game. (Sisters of St. Benedict, Ferdinand.)

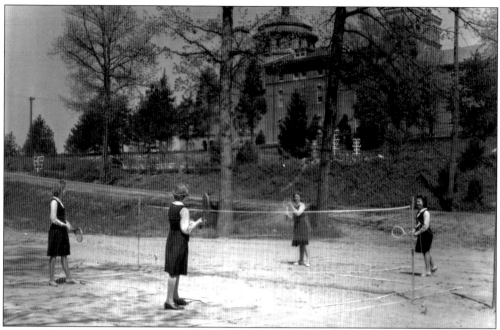

A part of the academy experience was becoming not only an educated person but also a young lady familiar with the appropriate social skills of the time. In the shadow of the monastery dome, this group of students at Academy Immaculate Conception is seen practicing badminton, a lawn game popular in educated society. (Sisters of St. Benedict, Ferdinand.)

For this Poor Clare sister, art and painting are both recreation and work. Her paintings decorate the walls at the Poor Clare Monastery in Evansville. In the spirit of humility that is the essence of the Poor Clare life, her works are all signed simply "A Poor Clare Sister." (Poor Clares, Evansville.)

A few of the sisters have found a way to incorporate their play into their missions. St. Joseph Sister Damien Fitzsimmons has become well known around Tipton for her appearances as Crackers the Clown. Sister Damien frequently entertains groups of children and the elderly and has appeared in local festivals. In the photograph st right, Sister Damien is acting as grand marshal of the Mardi Gras fund-raiser. Sister Damien's appearances bring a joyful presence at events all around the area as she smiles and laughs her way into people's hearts, proving that even God has a sense of humor. (Sisters of St. Joseph, Tipton.)

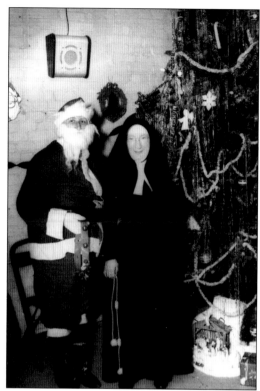

Although the jolly man is not a religious figure, Santa visited St. Francis Hospital in Beech Grove in the 1950s to bring the sisters a little respite from daily hospital operations. Hospital administrator Sister Mary Alexia poses with Santa at a holiday party for the sisters sponsored by the St. Francis Hospital Guild. (Beech Grove Public Library.)

Air travel on a vacation is common today, but in 1947 an overseas trip by airliner to visit family was an unexpected treat for a group of Sisters of St. Joseph who had all left Ireland to serve in Indiana. This picture taken aboard the Trans World Airliner just prior to departure from New York's LaGuardia Field proves that in this modern world, angels actually can fly. (Sisters of St. Joseph, Tipton.)

Seven

TODAY AND TOMORROW

Over the years a number of significant changes have impacted the religious communities and in some ways have altered public perception. Likely the most significant change in the view of the general public is the absence of the traditional religious habits since the 1960s. With this development the religious simply became less visible and not as easily recognized in the society at large. Other changes are simply the result of the development of social systems that have dramatically altered the fields in which the religious have traditionally served.

In education and healthcare the smaller locally operated schools and hospitals have merged and expanded in both size and scope. Hospital systems now include a number of general and specialty facilities spread over hundreds of miles, and the smaller arts and teaching colleges are now departments of major universities with a number of regional campuses. The Catholic elementary and high schools have reorganized to adapt to changing populations, growth of suburban housing, and the need for technology that is often beyond the capacity of a small local school.

In many ways it may appear that the religious communities have abandoned these missions. No longer does one see the sisters teaching in the elementary school, and the familiar white habit of the nursing sister is a rare sight in a modern hospital. But these are only appearances. Throughout Indiana today there are communities of active and engaged religious still working to shape the future of society and still serving the poorest of the poor. For these the work has been adapted to a new set of needs, different but no less important than the circumstances that first called them to the fledgling state nearly 175 years ago.

The religious communities brought to the church and society an extraordinary gift in the time of greatest need and took upon themselves the most difficult tasks. Today they still labor to bring God's peace, love, and compassion to the human condition.

Until the mid-1960s, the religious had been able to avoid the social issue of what dress was appropriate for work or for a formal gathering; their habit was the universal answer to fashion and style. With the modernization of Vatican II, choices had to be made about changes in the habits. The Our Lady of Victory Missionary Sisters tried a wide variety of styles, allowing the sisters to vote on a design. This 1967 photograph shows the options flanking the sister in the traditional habit of the order. Many of the communities had been wearing the same habit for a century, so there was a need for continuity along with the desire to adapt to modern society. Today a few communities have retained their traditional habit, a few have moved entirely away from the concept of a habit, and most have adopted some form of simple adaptation of a conservative style. (Our Lady of Victory Missionary Sisters Archives.)

The changes in technology have impacted many of the missions the religious have traditionally filled. Here is a Carmelite Sister in Terre Haute working at a computer station doing editing and typesetting for a religious publication, a remarkable difference from the hand stitching of vestments that was formerly a principal work of the sisters. (Archdiocese of Indianapolis Archives.)

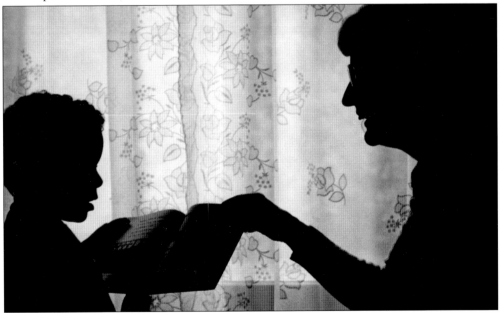

For nearly two centuries the children of Indiana have been nurtured and educated by the religious communities. Today the sisters are less in the classroom and more in the community centers working with transient or immigrant families, seeking justice for the marginalized among the population. But wherever it is done, teaching a child creates benefits for generations to come. (Sisters of St. Joseph, Tipton.)

The adaptation to new and different missions has not only affected the various sisters but also the Brothers of Holy Cross. The brothers long devoted their efforts to high school education, founding well-known schools such as Indianapolis Cathedral High School. Here Brother Chester Caster, M.D., stands outside his clinic in Petros, Tennessee, where he served the community and the needy. (Brothers of Holy Cross Archives.)

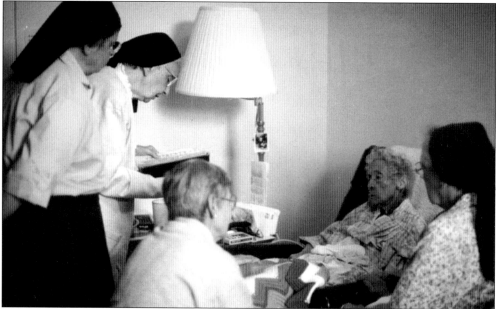

In a unique adaptation of their motherhouse, the Sisters of St. Joseph at Tipton have done major remodeling and opened a portion of their home to lay residents. The sisters do not operate this as a typical residential facility, but rather have the lay residents literally living among them, joining in prayer and meals and becoming a part of the general community. (Sisters of St. Joseph, Tipton.)

The Sisters of Providence have taken the reduction in their parish school assignments as an opportunity to put their teaching resources to use in programs for immigrants, as in this class teaching English to adults. The sisters have become very involved in a number of social justice programs serving the poor and immigrants throughout the area. (Sisters of Providence Provincial Archives.)

The Sisters of St. Francis at Oldenburg have for a century operated Michaela Farm at a site not far from the convent. This farm began by producing naturally grown produce and gradually became an agricultural laboratory long before the environmental movement was popular. The sisters saw a need to address environmental issues as a matter of social consciousness. Plans are underway to add solar and wind power along with specific landscaping features to improve the water and wildlife habitat on the farm. (Authors' collection.)

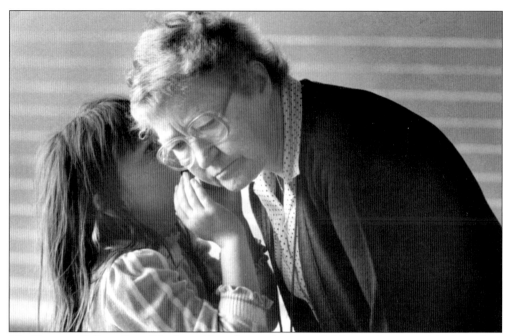

The Sisters of St Benedict of Ferdinand have been educating children and young adults from their earliest days in southern Indiana. Over the years the sisters have staffed more than 75 schools in 12 states and 5 countries. Sr. Mary Jean Davis may not be in the familiar habit of times past, but she is still the person to trust with a secret. (Sisters of St. Benedict, Ferdinand.)

Perhaps because of their fairly recent founding (1922), the Our Lady of Victory Missionary Sisters were more disposed to adopt new technology in their work than some of the orders that had centuries of tradition. The sisters were driving cars in the 1920s, and Sr. Rose Ann Kaiser was producing television programs in 1954. (Our Lady of Victory Missionary Sisters Archives.)

The Franciscan friars at Mount St. Francis have entered into another creative agricultural experiment. While some places have concentrated on the farming methods, the friars are working with a community group to focus on the farmers. This large garden on the grounds is especially designed to be accessible to persons with special needs. The gardeners come by bus on a regular basis to plant, tend, and harvest their crops. (Franciscan Friars, Mount St. Francis.)

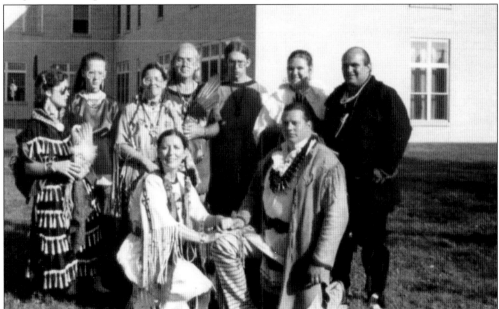

In the past several years there has been a resurgence in efforts of the Native American citizens to preserve their cultural traditions and history. The Sisters of St. Joseph at Tipton offered the use of space on their grounds for area Native American groups to have their holiday celebrations. This Cherokee celebration in 1992 was held on a space adjacent to the motherhouse. (Sisters of St. Joseph, Tipton.)

The Franciscan friars at Mount St. Francis operate a year-round retreat center in the former school buildings serving area groups. One specialty of the retreat center is providing retreat weekends for students of area Catholic high schools. High schools from all the nearby cities bring students for weekend retreats before graduation. (Friars of St. Francis, Mount St. Francis.)

Another adaptation of the grounds at Mount St. Francis is the hosting of local artists and craftspeople. The barn seen here has been converted to include studio space for various types of art, including large sculptures. Many of the large pieces on the grounds were created here. (Friars of St. Francis, Mount St. Francis.)

As the pace of life gets ever more frenetic, increasing numbers of people visit places to retreat and seek spiritual renewal. On former farmland near Bloomington, the Franciscan Friars and Sisters of the Immaculate offer a place for quiet reflection. The center has a guesthouse for those wishing to stay overnight and to accommodate weekend retreat programs for various groups. The expansive grounds include a walking path through the stations of the cross. Mass is offered daily in the on-site chapel. (Franciscan Friars of the Immaculate, Bloomington.)

Among the first missions the Sisters of St. Benedict were called to Beech Grove to fulfill was the establishment of a retirement home. St. Paul Hermitage was constructed on the western side of the monastery grounds in 1959, and after several renovations and the addition of a medical care wing, it still serves the community today. (Sisters of St. Benedict, Beech Grove,)

The Little Sisters of the Poor continue to serve Indianapolis from St. Augustine Home on the north side of the city. In 2006, the superior general of the Little Sisters, Mother Celine de la Visitation, made a canonical visit. Mother Celine is joined by (left) Bishop William L. Higi and (right) Archbishop Daniel M. Buechlein at St. Augustine Home. (Archdiocese of Indianapolis Archives.)

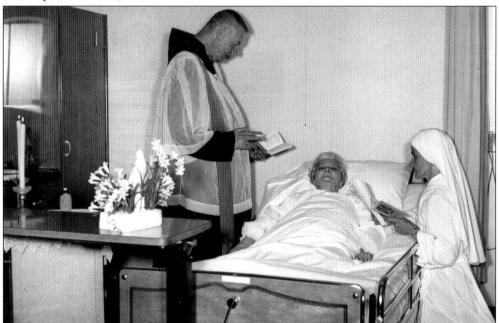

As much as some things in life change, others remain the same. At St. John Home for the Aged in Evansville the Little Sisters of the Poor minister to those approaching the end of life. The sisters have a tradition of never allowing a resident to die alone, so this sister will remain at the bedside to pray and comfort to the last moment. (Little Sisters of the Poor, Evansville.)

Over a century and a half ago, the first Catholic religious pioneers came to the wilderness of the young state of Indiana. Their missions brought skills in nursing, education, and social services to the immigrant communities in the cities, towns, and rural villages, building not only the church itself, but creating the institutions to address the human needs of each community. The fruits of their labors are visible in every city and smaller towns and villages; schools, hospitals, and social service centers that continue to be vital assets to the now modern society in Indiana. Throughout the seasons and the centuries the religious communities have remained as beacons of stability and hope in society. Shining through a blanket of winter ice and snow, the Castle on the Hill remains as it has for nearly 125 years with only a few signs of the ever-evolving missions of the sisters who pray and work for the good of all and call this peaceful place home. (Sisters of St. Benedict, Ferdinand.)

www.arcadiapublishing.com

Discover books about the town where you grew up, the cities where your friends and families live, the town where your parents met, or even that retirement spot you've been dreaming about. Our Web site provides history lovers with exclusive deals, advanced notification about new titles, e-mail alerts of author events, and much more.

MADE IN THE USA

Arcadia Publishing, the leading local history publisher in the United States, is committed to making history accessible and meaningful through publishing books that celebrate and preserve the heritage of America's people and places. Consistent with our mission to preserve history on a local level, this book was printed in South Carolina on American-made paper and manufactured entirely in the United States.

This book carries the accredited Forest Stewardship Council (FSC) label and is printed on 100 percent FSC-certified paper. Products carrying the FSC label are independently certified to assure consumers that they come from forests that are managed to meet the social, economic, and ecological needs of present and future generations.

FSC
Mixed Sources
Product group from well-managed
forests and other controlled sources

Cert no. SW-COC-001530
www.fsc.org
© 1996 Forest Stewardship Council

Find Your Place in History.